ACCENTS on ARTISTS
A Fact-Filled Pronunciation Guide

by Barbara and Peter Toohil

Publications Inc.

Note:
 The information in this book has been checked for accuracy
as closely as possible. The sources listed as references were used to
verify much of the book's content.

Published by Art 'N Facts Inc.
Manufactured in the U.S.A.

Library of Congress Cataloging in Publication Data

 ACCENTS on ARTISTS A Fact-Filled Pronunciation Guide
 Toohil, Barbara and Peter
 1 Pronunciations–Artists II Biography
 III. A Fact-Filled Pronunciation .
 Library of Congress Card Catalog Number 96 -94998
 ISBN 0-9655152-0-6

Contents:

Special thanks v
Introduction vi
Abbreviations explained vii
Pronunciations A-Z 2-361
References 362-363
Notes / sketch area

Cover:

Ginevra de' Benci, c.1474

by Leonardo DA VINCI

Wood, obverse: 15.25" x 14.50" (388 x 367 cm)

This is the only painting by Leonardo DA VINCI to be a part of an American collection.

Permanently housed in the Chester Dale Collection at the National Gallery of Art,

Washington, DC. Photo provided by Planet Art Photo Services

Special thanks

We especially want to thank our executive editor, Kara Parmelee, for her technical and substantive work on this book and its companion audio tape. Thanks also to David Evans for his technical input.

For the audio tape recording, a special thanks to the vocal talents of Marybeth Evans and Erika Funke, audio engineers Larry Vojiko and George Graham, and pianist Ron Stabinsky.

Introduction

This alphabetical list includes over 800 artists' names, each with a pronunciation, nationality, date of birth, and some notable facts to help you identify and become familiar with the artists.

Whether you work in museums, broadcasting, or the print media, or are simply an art lover, you will value this book as a quick and comprehensive guide to the top names in fine art, photography, video, and architecture.

The book's unique two-page format allows you extra space to jot down additional information. We encourage you not to let <u>ACCENTS on ARTISTS</u> sit quietly on a shelf, but rather to use it as a working notebook.

We hope that you have as much fun using <u>ACCENTS on ARTISTS</u> as we did in putting it together...ENJOY!

Abbreviations Explained

c. circa

b. date of birth

d. date of death

n.d. no date

f female

PC Private Collection

ACCENTS on ARTISTS
A Fact-Filled Pronunciation Guide

ABBOTT, Berenice **(AB–ut)**
American *f* (1898–1991)

ABBOTT, Lemuel Francis **(AB-ut)**
British (1760–1803)

ADAMS, Ansel **(AD-umz)**
American (1902–1984)

AELST, Willem van **(AHLST)**
Dutch (1626–1683)

AGASSE, Jacques-Laurent **(ag-AHS)**
Swiss (1767–1848)

ALBANI, Francesco **(al-BAH-nee)**
Italian/Bolognese (1578–1660)

FAST FACTS

Photographer | portraits of artists and writers working in Paris | *James Joyce* | *Jean Cocteau*

Portrait painter | *Captain Robert Calder,* c. 1790 (National Gallery of Art, Washington, DC)

Photographer | *Dunes Oceano, California,* c. 1948 (Library of Congress, Washington, DC)

Still-life painter | *Still Life with Dead Game,* 1661 (National Gallery of Art, Washington, DC)

Painter | *The Nubian Giraffe,* 1827 (The Royal Collection, Windsor Castle, Windsor, England)

Painter | painted over 40 alterpieces

ALBERS, Josef **(AL-berz)**
German (1888–1976)

ALBERTI, Leon Battista **(al-BEAR-tee)**
Italian (1407–1472)

ALDEGREVER, Heinrich **(AL-di-gray-ver)**
German (1502–c. 1560)

ALGARDI, Alessandro **(al-GAHR-dee)**
Italian/Bolognese (1602–1654)

ALLSTON, Washington **(ALL-stun)**
American (1779–1843)

FAST FACTS

Geometric abstractionist | painter | hard-edge painting | *Homage to the Square,* 1964 (The Tate Gallery, London, England)

Painter, poet, musician, philosopher, architect | designed many churches including San Francesco in Rimini, Italy and Sant'Andrea in Mantua, Italy

Portrait engraver, painter | ornamental engravings

Baroque sculptor | Bust of *Cardinal Paolo Emilio Zacchia* (Museo Nazionale del Bargello, Florence, Italy)

Painter, poet | romantic landscapes | studied with Benjamin West | *Moonlit Landscape,* 1819 (Museum of Fine Arts, Boston)

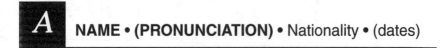
ALMA-TADEMA, Lawrence **(AHL-muh TAH-di-muh)**
Dutch (1836–1912)

ALTDORFER, Albrecht **(AHLT-dor-fer)**
German (c. 1480–1538)

AMIGONI, Jacopo **(am-mi-GO-nee)**
Italian/Venetian (1675–1752)

ANDERSON, Laurie **(AN-der-sun)**
American *f* (b. 1947)

ANDRE, Carl **(AHN-dray)**
American (b. 1935)

**ANDREA DEL CASTAGNO (ahn-DRAY-uh del cah-
STAHN-yo)** Italian/Florentine (c. 1423–1457)

6

FAST FACTS

Painter | *A Foregone Conclusion,* 1885 (The Tate Gallery, London, England)

Painter | Master of the Danube School | *The Battle of Issus* , 1529 (Alte Pinakothek, Munich, Germany)

Rococo painter | pastel-colored frescoes | *Bathsheba,* c. 1739–47 (Staaliche Museen Preussischer Kulturbesitz, Berlin, Germany)

Performance artist, video artist, musician | *United States Part, II,* 1980

Minimalist sculptor | *Lead Piece (144 Lead Plates 12 x 12 x 3/8"),* 1969 (The Museum of Modern Art, NYC)

Renaissance painter | frescoe of *The Last Supper*, c. 1445–1450 (Museo di Sant'Apollonia, Florence, Italy)

7

ANDREA DEL SARTO (ahn-DRAY-uh del SAHR-toe)
Italian/Florentine (1486–1531)

ANDREA DI BARTOLO (ahn-DRAY-uh di BAHR-toe-loe)
Italian/Sienese (active 1389–1428)

ANGELICO, Fra Beato **(frah bay-AH-toe an-JEL-li-co)**
Italian/Florentine (c. 1387–1455)

ANGUISSOLA, Sofonisba **(ahn-GWEE-soe-luh)**
Italian f (c. 1532–1625)

**ANTONELLO DA MESSINA
(an-toe-NEL-lo dah mes-SEE-nuh)**
Italian/Sicilian (c. 1430–1479)

Painter | *Birth of Saint John the Baptist,* 1526 (Palazzo Pitti, Florence, Italy)

Religious painter | *Crossing the Red Sea,* 1356–67 (Collegiata, San Gimignano, Italy)

Religious painter | *The Annunciation,* c. 1436 (Museo di San Marco, Florence, Italy)

Portraitist and Spanish Court painter | *Self Portrait,* c. 1600 (PC)

Painter | *The Martyrdom of Saint Sebastian,* 1475 (Staatliche Kunstsammlungen, Dresden, Germany)

APPEL, Karel **(AHP-pel)**
Dutch (b. 1921)

ARBUS, Diane **(AHR-bus)**
American *f* (1923–1971)

ARCHIMBOLDO, Giuseppe **(ahr-kim-BOWL-doe)**
Italian/Milanese (1537–1593)

ARCHIPENKO, Alexander **(ahr-chi-PEN-koe)**
American (b. Ukraine 1887–1964)

ARMITAGE, Kenneth **(AHR-mi-tazh)**
British (b. 1916)

FAST FACTS

Painter | member of the Cobra group | *Burned Face,* 1961 (PC)

Photographer | *Identical Twins, Roselle, NJ,* 1967 (The Art Institute of Chicago, Chicago, Illinois)

Painter | bizarre portrait heads composed of fruits, vegetables, and fish | *Summer,* 1573 (Musée du Louvre, Paris, France)

Cubist sculptor | *Boxers (Struggle),* 1914 (The Solomon R. Guggenheim Museum, NYC)

Sculptor | semi-abstract works of art | *Figure Lying on Its Side* (version 5), 1958–59 (The British Council, London, England)

A NAME • **(PRONUNCIATION)** • Nationality • (dates)

ARNOLFO DI CAMBIO (ahr-NOLE-foe di CAHM-bee-yo)
Italian (c. 1245–1302)

ARP, Jean or Hans **(AHRP)**
French (1887–1966)

ARPINO, Giuseppe Cesari **(ahr-PEE-noe)**
Italian (1560–1640)

ASPERTINI, Amico **(as-per-TEE-nee)**
Italian/Ferrarese-Bolognese (1475–1552)

ATGET, Eugène **(AHT-zhay)**
French (1857–1927)

12

FAST FACTS

Architect | designed the first plans for the Cathedral of Florence, Italy, in 1296

Abstract painter, sculptor | proponent of Automatic Drawing | founding member of the Dada movement | *The Forest*, 1916 (National Gallery of Art, Washington, DC)

Mannerist painter | frescoes in Santa Maria Maggiore in Rome, Italy, 1610–12

Painter | *Saint Sebastian,* c. 1505 (National Gallery of Art, Washington, DC)

Photographer | scenic photos of old Paris streets | *Corsets/379,* c. 1912 (The Art Institute of Chicago, Chicago, Illinois)

 NAME • (PRONUNCIATION) • Nationality • (dates)

AUDUBON, John James **(AW-doo-bahn)**
American (1785–1851)

AUERBACH, Frank **(OW-er-bahk)** British (b. 1931)

AVEDON, Richard **(AV-i-dahn)** American
(b. 1923)

AVERCAMP, Hendrik **(AH-ver-kahmp)**
Dutch (1585–1634)

AVERY, Milton **(AY-ver-ee)**
American (1885–1965)

Painter of North American birds and animals | Book, featuring *Birds of America,* (1826–1838) | *Spaniel Flushing English Pheasants* (American Museum of Natural History, NYC)

Painter | known for his portraits and views of London

Photographer | portraits, fashion photographs | worked for *Harper's Bazaar, Vogue,* and *New Yorker* magazines | *Brigitte Bardot,* 1959 (The Museum of Modern Art, NYC)

Painter | *Winter Landscape with Ice Skaters,* 1618 (The Rijkmuseum, Amsterdam, Holland)

Painter | abstract seaside scenes | *Spring Orchard,* 1959 (National Museum of American Art, Washington, DC)

BACON, Francis **(BAY-kun)**
British (b. Dublin 1910–1992)

BACON, John **(BAY-kun)**
British (1740–1799)

BAKST, Léon **(BAHKST)**
Russian (1866–1924)

BALDUCCIO, Giovanni di **(bal-DOO-cheeo)**
Italian/Pisan (active 1315–1349)

BALDUNG, Hans **(BAL-doong)**
German (c. 1484–1545)

Painter | *Head Surrounded by Sides of Beef*, 1954 (The Art Institute of Chicago, Chicago, Illinois)

Porcelain artist, modeler, and sculptor | designed tombs and monuments

Painter | theatrical designer for Diaghilev's *Ballets Russes* | *La Peri,* Arsenal Museum, Paris, France

Sculptor | worked c. 1335 on the Arca di San Pietro Martire at Saint Eustorgio in Milan, Italy

Painter, engraver | friend of Matthias Grünewald and probably a student of Albrecht Dürer | *The Three Ages of Man and Death,* 1539 (Museo del Prado, Madrid, Spain)

BALLA, Giacomo **(BAHL-luh)**
Italian (1871–1958)

BALTHUS (BAHL-toos) (Balthazar Klossowski de Rola)
French (b. Poland 1908)

BARENDSZ, Dirck **(BAHR-ents)**
Netherlandish (1534–1592)

BARNARD, George Grey **(BAHR-nerd)**
American (1863–1938)

BAROCCI, Frédérico **(bahr-ROH-chee)**
Italian/Roman(1526–1612)

Painter, lithographer | member of the Italian Futurist movement | *Dog on a Leash,* 1912 (The Museum of Modern Art, NYC)

Painter | known for depicting sensual subjects | *Nude with a Cat*, 1949 (National Gallery of Victoria, Melbourne, Australia)

Painter | portraits and historical subjects

Sculptor | *Struggle of the Two Natures in Man,* 1889–94

Painter | *Madonna del Popolo,* 1575-79 (Galleria degli Uffizi, Florence, Italy)

BARTHOLDI, Frédérick Auguste **(bahr-TOLE-dee)**
French (1834–1904)

BARTLETT, Jennifer **(BAHRT-let)**
American *f* (b. 1941)

BARTLETT, Paul Wayland **(BAHRT-let)**
American (1865–1925)

BARTOLOMMEO, Fra **(bahr-toe-loe-MAY-yo)**
Italian/Florentine (c. 1474–1517)

BARYE, Antoine Louis **(BAH-ree)**
French (1795–1875)

FAST FACTS

Sculptor | designed *The Statue of Liberty,* 1884 located at the New York City Harbor entrance on Bedloe's Island

Painter, photographer, sculptor, printmaker | *Summer Lost at Night (for Tom Hess)*, 1978 (The Museum of Modern Art, NYC)

Sculptor | studied in France | heroic portraits | *The Bear Tamer*

Painter | *Marriage of Saint Catherine I,* 1511 (Musée du Louvre, Paris, France)

Sculptor, painter, watercolorist | known for his portrayal of animals

BASCHENIS, Evaristo **(bas-ken-NEE)**
Italian (1617–1677)

BASELITZ, Georg **(BAH-zeh-lits)**
European (b. 1938)

BASKIN, Leonard **(BAS-kin)**
American (b. 1922)

BASQUIAT, Jean-Michel **(bas-kee-AH)**
American (1960–1986)

BASSANO, Jacopo **(bah-SAH-noe)**
Italian (1510–1592)

FAST FACTS

Painter | impeccable still lifes with musical instruments

Painter | founder of the Neo-Expressionist movement | known for his upside down images | *Adieu*, 1982 (The Tate Gallery, London, England)

Printmaker, sculptor | large-scale figures in stone, wood, and bronze

Painter, graffiti artist | movie *Basquiat* made by artist and director Julian Schnabel, 1996

Painter, Venetian School | one of the earliest Italian genre painters | frescoes in the Piazza Ponte Vecchio, Florence, Italy | *Lazarus and Dives*, (Cleveland Museum of Art, Ohio)

BASTIEN-LEPAGE, Jules **(bas-tee-e(n) leh-PAZH)**
French (1848–1884)

BATONI, Pompeo **(bah-TOE-nee)**
Italian (1708–1787)

BAUGIN, Lubin **(boe-ga(n))**
French (c. 1610–1663)

BAUM, Charles **(BOWM)**
American (1812–1877)

BAUMEISTER, Willi **(BOW-my-ster)**
German (1889–1955)

Painter, sculptor, printmaker | portraits | rustic scenes | *Hay Field,* 1877 (Musée du Louvre, Paris, France)

Portrait painter | painted over 22 sovereigns | historical and mythical subjects

Painter | still lifes | best known for paintings of the Holy Family

Still-life painter | French School

Painter | abstract Surrealist | murals | studied under Oscar Schlemmer | *Mortaruru with Red Overhead* (PC)

BAZILLE, Frédéric **(bah-ZEE)**
French (1841–1870)

BEARDEN, Romare **(BEER-den)**
American (1912–1988)

BEARDSLEY, Aubrey **(BEERD-slee)**
English (1872–1898)

BEAUNEVEU, André **(boe-neh-VEU)**
French (1361–c. 1402)

FAST FACTS

Painter | early Impressionist (died before the first Impressionist exhibition in 1874) | *Negro Girl with Peonies,* 1870 (National Gallery of Art, Washingon, DC)

Painter | collage | known for his enlarged photomontages | scenes of African-American urban life | *Serenade*, 1968–69 (Madison Art Center, Madison, Wisconsin)

Illustrator | Art Nouveau | pen and ink drawings | posters | *The Toilette of Salomé*, 1894 (illustration from Oscar Wilde's *Salome*) (Collection of Mr. H. S. Nicols)

Painter, sculptor, illuminator | manuscripts and religious themes

 NAME • (PRONUNCIATION) • Nationality • (dates)

BEAUX, Cecilia **(BOE)**
American *f* (1855–1942)

BECCAFUMI, Domenico **(bek-kuh-FOO-mee)**
Italian/Sienese (1486–1551)

BECKMANN, Max **(BEK-mahn)**
German (1884–1950)

BEERBOHM, Max **(BEER-bahm)**
English (1872–1956)

BEHAM, Hans **(BAY-hum)**
German (1500–1550)

Impressionist painter, portraitist | *Man with the Cat (Henry Surgis Drinker),* 1898 (National Museum of American Art, Washington, DC)

Painter | paintings and frescoes in Sienese churches | *The Fall of the Rebel Angels,* c. 1526 (Pianc Nazionale, Siena, Italy)

Expressionist painter, graphic artist | *Night,* 1918–19 (Kunstsämmlung Nordrhein-Westphalen, Düsseldorf, Germany)

Writer, caricaturist, satirist, draftsman | nicknamed "The Incomparable Max" | *Twenty-Five Gentlemen,* 1896

Painter, engraver | woodcuts | made over 1,000 book illustrations

BELL, Vanessa **(BELL)**
English *f* (1879–1961)

BELLA, Stefano della **(BEL-luh)**
Italian/Florentine (1610–1664)

BELLINI, Gentile **(behl-LEE-nee)**
Italian/Venetian (c. 1429–1507)

BELLINI, Giovanni **(behl-LEE-nee)**
Italian/Venetian (c. 1430–1516)

Painter, designer, decorative artist | sister of writer Virginia
Woolf | influenced by the Fauves

Engraver, draftsman | landscapes and battle scenes |
many of his works are in the Royal Library at Windsor
Castle, Windsor, England

Painter | artist Jacopo Bellini's elder son | *The Miracle of
the Cross on the Bridge of San Lorenzo*, 1500 (Galleria
dell'Accademia, Venice, Italy)

Painter | portraits and religious themes | madonnas
painted as altarpieces | considered the founder of
Venetian style | artist Jacopo Bellini's younger son |
Saint Francis in Ecstasy, c. 1485 (The Frick Collection, NYC)

NAME • (PRONUNCIATION) • Nationality • (dates)

BELLINI, Jacopo **(behl-LEE-nee)**
Italian/Venetian (c. 1400–1470)

BELLMER, Hans **(BEL-mer)**
French (b. Poland 1902–1975)

BELLOTTO, Bernardo **(bel-LAHT-toe)**
Italian (1720–1780)

BELLOWS, George Wesley **(BEL-loes)**
American (1882–1925)

FAST FACTS

Painter | heralded the Renaissance in Venice, Italy | father of Gentile and Giovanni Bellini | *The Baptism of Christ,* c. 1430–40 (British Museum, London, England)

Surrealist painter | *The Spinning Top,* c. 1937–56 (The Tate Gallery, London, England)

Painter | also known as Canaletto the Younger | *Dresden from the Right Bank of the Elbe,* 1748 (Gemäldegalerie, Dresden, Germany)

Painter, lithographer | member of the Ashcan School | boxing scenes | *Stag at Sharkey's,* 1907 (The Cleveland Museum of Art, Cleveland, Ohio) | *Dempsey and Firpo,* 1924 (Whitney Museum of American Art, NYC)

BENOIS, Aleksandr **(ben-WAH)**
Russian (1870–1950)

BENTON, Thomas Hart **(BEN-tun)**
American (1889–1975)

BÉRAUD, Jean **(bear-ROE)**
French (b. Russia 1849–1936)

BERNINI, Gianlorenzo **(bear-NEE-nee)**
Italian (1598–1680)

BEUYS, Josef **(BOYS)**
German (1921–1986)

Painter, art historian, critic | costume and set designer for Diaghilev's *Ballets Russes* | *Giselle,* 1910 and *Petrushka,* 1911

Painter, muralist | depicted American farm life in the Midwest, 1920s and 1930s | *Poker Night,* 1948 (scene from the play *A Streetcar Named Desire*)

Religious, genre, and portrait painter | *Paris, Rue du Havre*, c. 1882 (National Gallery of Art, Washington, DC)

Baroque sculptor | portrait busts | *The Ecstasy of Saint Theresa,* 1647–52 (Santa Maria della Vittoria, Rome, Italy)

Sculptor, performance artist, and video artist | *Felt Suit,* 1970 (PC)

BIERSTADT, Albert **(BEER-shtaht)**
American (b. Germany 1830–1902)

BINGHAM, George Caleb **(BING-um)**
American (1811–1879)

BLAINE, Nell **(BLAYN)**
American *f* (b. 1922)

BLAKE, Peter **(BLAYK)**
British (b. 1932)

BLAKE, William **(BLAYK)**
British (1757–1827)

FAST FACTS

Painter | mountains and landscapes |
Indian Encampment in the Rockies, n.d. (Whitney Gallery
of Western Art, Cody, Wyoming)

Painter | portraits | landscapes of American frontier life |
Fur Traders Descending the Missouri, 1845 (The Metropolitan
Museum of Art, NYC)

Painter | landscapes, interiors, and still lifes | *Night
Lights, Snow*, 1994 (Fishbach Gallery, NYC)

Painter | *On the Balcony*, 1955–57 (The Tate Gallery, London,
England)

Painter, engraver, poet | scenes from The Bible, Dante,
and Milton | *God Creating the Universe,* c. 1794 (Fitzwilliam
Museum, Cambridge, England)

 NAME • (PRONUNCIATION) • Nationality • (dates)

BLAKELOCK, Ralph Albert **(BLAYK-lahk)**
American (1849–1919)

BLOCH, Martin **(BLAHK)**
German (1883–1954)

BLOEMAERT, Abraham **(BLOO-mayrt)**
Dutch (1564–1651)

BLYTHE, David Gilmour **(BLYTH)**
American (1815–1865)

BOCCIONI, Umberto **(bah-CHOE-nee)**
Italian (1882–1916)

FAST FACTS

Landscape painter | *Indian Encampment*, c. 1885–89
(National Museum of American Art, Washington, DC)

Painter | landscapes and town scenes | *The Cocoon Market at Mantua*, 1928 (National Gallery of Art, Washington, DC)

Painter | *Judith Showing the People the Head of Holofernes*, 1593 (Kunsthistorisches Museum, Vienna, Austria)

Genre painter, satirist, caricaturist | *Libby Prison*, c. 1864 (Museum of Fine Arts, Boston)

Painter, sculptor | member of the Futurist movement | *States of Mind: The Farewells*, 1911 (PC, NYC)

BÖCKLIN, Arnold **(BEUK-lin)**
Swiss (1827–1901)

BOLDINI, Giovanni **(bole-DEE-nee)** Italian
(1842–1931)

BOLTANSKI, Christian **(bole-TAN-skee)**
French (b. 1944)

BOMBOIS, Camille **(boam-BWAH)** French (1883–1966)

BONHEUR, Rosa **(boe-NER)**
French f (1822–1899)

BONINGTON, Richard Parkes **(BAHN-ing-tun)**
British (1801–1828)

FAST FACTS

Symbolist painter | supernatural and dreamlike scenes |
The Island of the Dead, 1880 (The Metropolitan Museum of Art, NYC)

Painter | society portaits | *Consuelo, Duchess of Marlborough,
with her son Lord Iver Spencer-Churchill,* 1906

Sculptor, conceptual artist | themes of death and mortality

Self-taught painter | *The Cow,* 1928 (Soufer Gallery, NYC)

Genre painter | *Horse Fair* (The Metropolitan Museum of Art, NYC)
| *Colonel William F. "Buffalo Bill" Cody* (The Whitney Gallery of
Western Art, Cody, Wyoming)

Landscape painter | lived in France | *View of the
Parterre d'Eau at Versailles,* 1825 (Musée du Louvre, Paris, France)

BONNARD, Pierre **(boe-NAHR)**
French (1867–1947)

BONTECOU, Lee **(BAHN-ti-coo)**
American f (b. 1931)

BORDONE, Paris **(bore-DOAN)**
Italian/Venetian (1500–1571)

BORGLUM, Gutzon **(BORE-glum)**
American (1871–1941)

BORGLUM, Solon Hannibal **(BORE-glum)**
American (1868–1922)

Painter | *Dining Room in the Garden,* 1934–35 (The Solomon R. Guggenheim Museum, NYC)

Abstract sculptor, printmaker | welded steel and canvas compositions | *Untitled*, 1964 (Honolulu Academy of Arts, Hawaii)

Painter | pupil of Titian | *Consigning of the Ring to the Doge,* 1535 (Galleria dell' Accademia, Venice, Italy)

Sculptor | public sculpture | Presidential portraits at Mount Rushmore, 1927–41 (The Black Hills, South Dakota)

Sculptor | brother of Gutzon Borglum | commissioned for the great Lousiana Purchase Exposition | subjects included horses, cowboys, and Native Americans of the Western frontier

BOROFSKY, Jonathan **(bore-OFF-skee)**
American (b.1942)

BOSCH, Hieronymous **(BAHSH)**
Dutch (c. 1450–1516)

BOTERO, Fernando **(boe-TARE-oe)**
South American (b. 1933)

BOTTICELLI, Sandro **(bah-ti-CHEL-lee)**
Italian (c. 1445–1510)

BOUCHER, François **(boo-SHAY)**
French (1703–1770)

Painter, sculptor, printmaker, installation artist |
Hammering Man at 2,772,489 (JB27 sculp), 1981 (Kunsthalle, Basel, Germany)

Painter | *The Garden of Earthly Delights,* after 1500 (Museo del Prado, Madrid, Spain)

Sculptor | *La Familia Pinzon* (rotund bronze sculptures along Park Avenue, NYC)

Renaissance painter | *The Birth of Venus,* mid-1480s, and *Primavera,* c. 1482 (both at Galleria degli Uffizi, Florence, Italy)

Rococo painter, engraver | court painter to Louis XV | *Reclining Girl,* 1752 (The Alte Pinakothek, Munich, Germany)

NAME • (PRONUNCIATION) • Nationality • (dates)

BOUDIN, Eugène **(boo-DA(N))**
French (1824–1898)

BOUGUEREAU, Adolphe-William **(BOO-ge-roe)**
French (1825–1905)

BOURDELLE, Antoine **(boor-DEL)**
French (1861–1929)

BOURGEOIS, Louise **(boor-ZHWAH)**
American ƒ (b. France 1911)

FAST FACTS

Painter | known for his luminous seaside scenes |
On the Beach, Trouville, 1877 (National Gallery of Art, Washington, DC)

Painter | erotic, mythological scenes | advocate of
The French Salon (19thc)

Sculptor, painter | assistant to Auguste Rodin | *Herakles,*
1908 (Musée Bourdelle, Paris, France)

Surrealist sculptor, painter | *Sleeping Figure,* 1950 (The
Museum of Modern Art, NYC) | *One and Others,* 1955 (Whitney
Museum of American Art, NYC)

BOURKE-WHITE, Margaret **(BOORK-WYT)**
American ƒ (1904–1971)

BOUTS, Dirk **(BOWTS)**
Netherlandish (c. 1420–1475)

BOYD, Arthur **(BOYD)**
Australian (b. 1920)

BRACQUEMOND, Félix **(brahk-MOHND)**
French (1833–1914)

BRADY, Mathew **(BRAY-dee)**
American (1823–1896)

FAST FACTS

Photographer, writer | photos in *Fortune* and *Life* | first accredited woman war correspondent to go overseas during WWII | *The Spinner, India,* 1946 | *At the Time of the Louisville Flood,* 1937 (George Eastman House, Rochester, New York)

Flemish painter | linear perspective | *The Way to Paradise,* 1450 (Musée des Beaux-Arts, Lille, France)

Painter, ceramicist | *Shearers Playing for a Bride,* 1957 (National Gallery of Victoria, Melbourne, Australia)

Engraver, painter | *Upper Part of the Leaf of the Door,* 1852 | exhibited in the first Impressionist exhibition in 1874

Documentary photographer during the Civil War | *Ruins of Richmond, Virginia,* 1865 (The Museum of Modern Art, NYC)

BRANCUSI, Constantin **(bran-COO-zee)**
Romanian (1876–1957)

BRANDT, Bill **(BRANT)**
British (1906–1983)

BRANSOM, Paul **(BRAN-sum)**
American (1885–1981)

BRAQUE, Georges **(BRAHK)**
French (1882–1963)

BRASSAÏ (Gyula Halász) **(brah-SIGH)**
French (b.Romania 1899–1984)

FAST FACTS

Sculptor | lived in Paris | *The Kiss,* 1908 (Philadelphia Museum of Art, Philadelphia, Pennsylvania) | *Bird in Space*, 1925 (Collection of W.A.M. Burden, NYC)

Photographer | *At "Charlie Brown's," London*, c. 1936 (The Museum of Modern Art, NYC)

Painter and illustrator of animal stories | covers for *The Saturday Evening Post* magazine

Cubist painter | created Cubism with Picasso | *Violin and Palette,* 1909–10 (The Solomon R. Guggenheim Museum, NYC)

Photographer | scenes of nocturnal Paris in the 1930s | *"Bijou" of Montmartre,* 1933 (The Museum of Modern Art, NYC) | *Untitled (Streetwalker),* 1932 (The Art Institute of Chicago, Chicago, Illinois)

BRETON, Jules **(bre-TOHN)**
French (1827–1906)

BREUER, Marcel **(BROY-er)**
American (b. Hungary 1902–1981)

BRONZINO, Agnolo **(brahn-ZEE-noe)**
Italian/Florentine (1503–1572)

BROODTHAERS, Marcel **(BROTE-hares)**
Belgian (b. 1924)

BROUWER, Adriaen **(BROW-er)**
Flemish (1605–1638)

FAST FACTS

Painter of rural and peasant life │ *Song of the Lark*

Architect, furniture designer │ created sleek furniture
designs in tubular steel │ "Club Chair," 1927–28

Mannerist painter │ known for his society portraits │ *An
Allegory with Venus and Cupid,* mid-1540s (The National Gallery,
London, England)

Sculptor, conceptual artist │ *Casserole and Closed
Mussels,* 1964–65 (The Tate Gallery, London, England)

Painter │ Flemish School │ *Boors Drinking,* c. 1620s (The
National Gallery, London, England)

BROWN, Ford Madox **(BROWN)**
British (1821–1893)

BRUEGEL, Pieter the Elder **(BROY-gel)**
Flemish-Netherlandish (c. 1525–1569)

BRUNELLESCHI, Filippo **(broo-ne-LES-kee)**
Italian/Florentine (1377–1446)

BUREN, Daniel **(BYOOR-en)**
French (b. 1939)

Painter | associated with the Pre-Raphaelite Brotherhood
| *The Last of England,* 1855 (City Art Gallery, Birmingham, England)

Painter of peasant life | called "Peasant Bruegel" | *The Return of the Hunters,* 1565 (also known as *Winter*)
(Kunsthistorisches Museum, Vienna, Austria)

Renaissance architect | designed one of the great Italian palazzos, the Pitti Palace in Florence | invented the single-vanishing-point perspective

Large-scale earthworks | Black-and-white sculpture for the Cour d'Honneur at the Palais-Royal in Paris, 1985–86

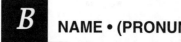

BURNE-JONES, Edward Coley **(BURN-JONES)**
British (1833–1898)

BURRA, Edward **(BUH-ruh)**
British (1905–1976)

NOTES:

Painter and decorative artist | founded the second Pre-Raphaelite Brotherhood with William Morris and Dante Gabriel Rossetti | *The Golden Stairs,* 1880 (The Tate Gallery, London, England)

Surrealist painter, theatrical designer | painted satirical scenes, mostly in watercolor

CABANEL, Alexander **(ka-bah-NEL)**
French (1823–1889)

CADMUS, Paul **(KAD-mus)**
American (b. 1904)

CAILLEBOTTE, Gustave **(ky-yuh-BOHT)**
French (1848–1894)

CALDER, Alexander **(KAWL-der)**
American (1898–1976)

CALLOT, Jacques **(kal-LOE)**
Italian (b. France c. 1592–1635)

FAST FACTS

Painter, printmaker | organized the annual Salon in Paris
| *Birth of Venus,* 1863 (Musée du Louvre, Paris, France)

Painter, art patron | *Bar Italia,* 1953–55 (National Museum of
American Art, Washington, DC)

Painter | *Paris Street, Rainy Day,* 1876–77 (The Art Institute of
Chicago, Chicago, Illinois)

Sculptor | designed hanging mobiles | *Lobster Trap and
Fish Tail,* 1939 (The Museum of Modern Art, NYC)

Painter | *The Temptation of Saint Anthony,* c. 1616 |
The Fair at Impruneta, c. 1620

CAMERON, Julia Margaret **(KAM-er-ahn)**
British *f* (1815–1879)

CAMPIN, Robert **(KAM-pin)**
Netherlandish (c. 1378–1444)

CANALETTO (ka-nah-LET-toe) Giovanni Antonio Canal
Italian/Venetian (1697–1768)

CANOVA, Antonio **(kahn-NOE-vuh)**
Italian (1757–1822)

CAPA, Robert **(KAP-uh)**
American (b. Hungary 1913–1954)

Photographer | albumen silver prints | *Portrait of Ellen Terry*

Painter | frescoes and cartoons for tapestries | believed to be the Master of Flémalle

Painter | views of Venice, Italy | used the camera obscura to outline his compositions

Neoclassical sculptor | *Winged Victory,* c. 1803-1806 (National Gallery of Art Washington, DC) | *Cupid and Psyche,* 1787-93 (Villa Carlotta, Lake Como, Italy)

Photographer | covered the Spanish Civil War, WWII, and Vietnam | worked for *Life* and *Collier's* magazines

CARAVAGGIO, Michelangelo Merisi da **(ka-rah-VAH-joe)**
Italian (1571–1610)

CARO, Anthony **(KA-roe)**
British (b. 1924)

CAROLUS-DURAN, Charles-Émile-Auguste
(ka-roe-lus duh-RAN) French (1838–1917)

CARPACCIO, Vittore **(kahr-PAH-choe)**
Italian (c. 1455-1526)

FAST FACTS

Early Baroque painter | known for his use of "chiaroscuro", technique of contrasting lights and darks | *The Fortune Teller,* C. 1594–95 (Musée du Louvre, Paris, France)

Sculptor | uses prefabricated metal pieces in his work | *Source,* 1967 (The Museum of Modern Art, NYC)

Painter | teacher of artist John Singer Sargent

Painter | Venetian School | painted scenes of Venice | *Saint Augustine in his Study,* c. 1510 (Scuolo di San Giorgio degli Schiavoni, Venice, Italy)

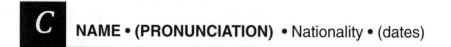

C NAME • **(PRONUNCIATION)** • Nationality • (dates)

CARPEAUX, Jean-Baptiste **(kahr-POE)**
French (1827–1875)

CARRÀ, Carlo **(kahr-RAH)**
Italian (1881–1966)

CARRACCI, Agostino **(kah-RAH-chee)**
Italian/Bolognese (1557–1602)

CARRACCI, Annibale **(kah-RAH-chee)**
Italian/Bolognese (1560–1609)

FAST FACTS

Sculptor, painter, printmaker | *The Dance,* 1866–69 (made for the façade of the Paris Opera)

Painter | original member of the Futurist group | formed the "Metaphysical Painting" movement with Giorgio de Chirico | *Funeral of the Anarchist Galli,* 1911 (The Museum of Modern Art, NYC)

Painter | brother of artist Annibale Carracci | *The Last Communion of Saint Jerome,* 1593–94 (Pinacoteca, Bologna, Italy)

Painter | known for painting murals and ceilings | one of a family of painters, Annibale was considered the most talented | *The Flight into Egypt,* c. 1603 (Doria Pamphili Gallery, Rome, Italy)

CARRACCI, Ludovico **(kah-RAH-chee)**
Italian/Bolognese (1556–1619)

CARRIERA, Rosalba **(kah-ree-AIR-uh)**
Venetian *f* (1675–1757)

CARRIÈRE, Eugène **(kah-ree-AIR)**
French (1849–1906)

CARTIER-BRESSON, Henri **(CAHR-tee-yay BRE-sohn)**
French (b. 1908)

Painter | cousin to Agnostino and Annibale Carracci |
The Flagellation (Musée de la Chartreuse, Douai, France)

Painter, portrait artist, miniaturist | Rococo style | pastelist
| portraits of nobility | *Self-Portrait with an Image of the
Artist's Sister,* 1709 (Galleria degli Uffizi, Florence, Italy)

Painter, portraitist | themes of motherhood

Photographer | documentary work | *Sunday on the
Banks of the Marne,* 1939 (The Museum of Modern Art, NYC) |
Seville, 1933 (Magnum Photos, NYC)

CASSANDRE, A. M. **(kas-AHN-dr(uh))**
French (b. Ukraine 1901–1986)

CASSATT, Mary **(kuh-SAHT)**
American ƒ (1844–1926)

CATLIN, George **(KAT-lin)**
American (1796–1872)

CELLINI, Benvenuto **(che-LEE-nee)**
Italian (1500–1571)

CÉZANNE, Paul **(say-ZAHN)**
French (1839–1906)

FAST FACTS

Poster artist | *Nord Express,* 1927 | *L'Atlantique,* 1931 | *Normandie,* 1935 (all 3 versions Collection of Susan J. Pack)

Painter, printmaker | associated with the French Impressionists | images of mothers and children | *The Bath,* 1891–92 (The Art Institute of Chicago, Chicago, Illinois)

Painter of Native Americans | explorer | *See-non-ty-a, an Iowa Medicine Man,* 1844–45 (National Gallery of Art, Washington, DC)

Renaissance artist, sculptor, and goldsmith | *Perseus with the Head of Medusa,* 1554 (Loggia dei Lanzi Florence, Italy)

Painter | Post-Impressionist | *La Montagne Sainte-Victoire,* 1904–06 (Philadelphia Museum of Art, Philadelphia, Pennsylvania)

CHAGALL, Marc **(shah-GAHL)**
Russian (1887–1985)

CHAMBERLAIN, John **(CHAYM-ber-lin)**
American (b. 1927)

CHAMPAIGNE, Philippe de **(shahm-pine-yuh)**
French (b. Flanders 1602–1674)

CHARDIN, Jean-Baptiste-Siméon **(shar-DA(N))**
French (1699–1779)

FAST FACTS

Painter | dreamlike scenes | worked in France | *Moi et le Village,* 1911 (The Museum of Modern Art, NYC)

Sculptor | uses discarded metals and crushed automobile parts in his works

Painter | portraits, landscapes, religious works | *La Mère Catherine-Agnès Arnaud et la soeur Catherine de Sainte-Suzanne*, 1662 (Musée du Louvre, Paris, France)

Painter | still lifes and genre scenes | *The Kitchen Maid*, 1738 (National Gallery of Art, Washington, DC)

CHASE, William Merritt **(CHASE)**
American (1849–1916)

CHIA, Sandro **(KEE-uh)**
Italian (b. 1946)

CHICAGO, Judy **(shi-KAH-goe)**
American *f* (b.1939)

CHIHULY, Dale **(chee-OO-lee)**
American (b. 1941)

CHIRICO, Giorgio de **(KEE-ri-koe)**
Italian (b. Greece 1888–1978)

Painter, teacher | still lifes,landscapes,portraits | *Shinnecock Hills, Long Island,* 1900 (The White House, Washington, DC)

Painter | Neo-Expressionist | *Incident at the Cafe Tintoretto,* 1981

Painter, sculptor | designer and supervisor of the collaborative project *The Dinner Party,* 1973–79 (stored in California)

Glass sculptor | craft-as-art

Surrealist painter | haunting metaphysical cityscapes | *Conversation Among the Ruins,* 1927 (National Gallery of Art, Washington, DC)

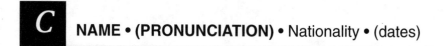
CHRISTO, (KRIS-toe) Christo Vladimirov Jaracheff
Bulgarian (b. 1935)

CHRISTUS, Petrus **(KRIS-tus)**
Flemish (c. 1410–1472)

CHURCH, Frederic Edwin **(CHERCH)**
American (1826–1900)

CIMA DA CONEGLIANO, Giovanni Battista
(CHEE-muh di coe-ni-lee-AH-noe)
Italian/Venetian (1459–1517)

FAST FACTS

Earth artist, land sculptor | wraps land masses and build-ings with large swaths of fabric | *Running Fence*, 1976 California | *The Pont Neuf*, 1985, Paris, France

Painter | followed the style of Jan van Eyck | *Portrait of a Young Woman,* c. 1450 (Gemäldegalerie, Berlin-Dahlem, Germany)

Landscape painter, photographer | views of Niagara Falls, the Andes and the Arctic | *Cotopaxi,* 1857 (The Art Institute of Chicago, Chicago, Illinois)

Painter | *Saint Helena,* c. 1495 (National Gallery of Art, Washington, DC)

CIMABUE Cenni di Peppi **(chi-muh-BOO-eh)**
Italian/Florentine (1240–1302)

CLAESZ, Pieter **(KLAHS)**
Dutch (1597–1661)

CLAUDEL, Camille **(kloe-DEL)**
French f (1864–1943)

CLEMENTE, Francesco **(kle-MEN-tay)**
Italian (b.1952)

CLOSE, Chuck **(KLOCE)**
American (b. 1940)

Painter | Cimabue means "ox head" | Madonnas |
Giotto's teacher | *Virgin in Majesty,* after c. 1270 (the oldest
Western painting in the Louvre Museum, Paris , France)

Still-life painter | Dutch school | "breakfast" paintings |
A Vanitas Still Life, 1645 (PC)

Sculptor | worked with Auguste Rodin | *Maturity (L'Age
Mûr),* 1895 (Musée d'Orsay, Paris, France)

Painter | Neo-Expressionist | *Not St.Girolamo,* 1981 (The
Museum of Modern Art, NYC)

Painter, photographer | oversized images (portraits) |
Robert/104,072, 1973–74 (The Museum of Modern Art, NYC)

CLOUET, François **(kloo-AY)**
French (c. 1522–1572)

COCTEAU, Jean **(kohk-toe)** French (1889–1963)

COLE, Thomas **(KOLE)**
American (1801–1848)

COLLEY, Amy Griffith **(CAH-lee)**
American *f* (b. 1961)

COLLEY, Stephen **(CAH-lee)**
American (b. 1962)

FAST FACTS

Painter │ *Lady Bathing with Children and Attendants,*
c. 1571 (National Gallery of Art, Washington, DC)

Designer, filmmaker, novelist, playwright, and poet │
Parade, ballet created with Eric Satie and Pablo Picasso

Painter │ often called the father of American landscape
painting │ Hudson River scenes │ *The Oxbow,* 1836 (The
Metropolitan Museum of Art, NYC) │ *The Voyage of Life: Youth,*
1842 (National Gallery of Art, Washington, DC)

Painter, collagist, teacher │ *Mother and Child #2 ,* 1992
(Gene Reed Gallery, Nyack, New York - Collection of the artist)

Sculptor, painter, teacher │ *Nude in Studio with Cat,* 1992
(Collection of the artist)

79

NAME • (PRONUNCIATION) • Nationality • (dates)

CONSTABLE, John **(KAHN-stuh-bull)**
British (1776–1837)

COPLEY, John Singleton **(KAHP-lee)**
American (1738–1815)

CORBUSIER, LE (leh kor-BOO-SEE-ay)
(Charles Édouard Jeanneret)
French (b. Switzerland 1888–1965)

CORINTH, Lovis **(KOR-inth)**
German (1858–1925)

CORNELL, Joseph **(kor-NEL)** American (1903–1973)

FAST FACTS

Landscape painter | *The Hay Wain,* 1821 (The National Gallery, London, England)

Painter | portraits of colonial Americans and the British | *Watson and the Shark,* 1778 (Museum of Fine Arts, Boston)

Architect, writer, painter | designed houses as "machines for living" | *Notre-Dame-du-Haut,* Ronchamp, France 1950-55

Impressionist painter | *The Red Christ,* 1922 (Neue Pinakothek, Munich, Germany) | *Morning Sunlight,* 1910

Collagist, sculptor | worked with found objects | *Rose Castle,* 1945 (Whitney Museum of American Art, NYC)

81

COROT, Jean-Baptiste-Camille **(kor-ROE)**
French (1796–1875)

CORREGGIO, Antonio Allegri **(kor-REJ-joe)**
Italian (1489–1534)

COSSA, Francesco del **(KOS-sah)**
Italian (c. 1436–1478)

COURBET, Gustave **(koor-BAY)**
French (1819–1877)

COUTURE, Thomas **(koo-TOUR)**
French (1815–1879)

FAST FACTS

Painter | landscapes, figures, portraits | taught Camille
Pissarro | *Cathedral of Chartres,* 1830 (Musée du Louvre, Paris, France)

Renaissance painter | frescoes, altarpieces | *Leda and the Swan,* c. 1530 (Staatliche Museen, Berlin-Dahlem, Germany)

Painter | responsible for three of the twelve frescoes in the *Hall of the Months* (Palazzo Schifanoia, Ferrara, Italy)

Realist painter | *Interior of My Studio, a Real Allegory Summing Up Seven Years of My Life as an Artist,* 1854–85 (Musée du Louvre, Paris, France)

Painter | taught artist Édouard Manet | *Romans of the Decadence,* 1847 (Musée d'Orsay, Paris, France)

COVARRUBIAS, Miguel **(ko-vuh-ROO-bee-yus)**
Mexican (1902–1957)

COYPEL, Charles-Antoine **(KWA-pel)**
French (1661–1722)

COZENS, Alexander **(KUH-zenz)**
British (c. 1717–1786)

CRAGG, Tony **(KRAG)**
British (b. 1949)

Painter, caricaturist

Painter and decorator │ *L'Olympe* (a sketch on canvas for the ceiling of the Galerie d'Énée in the Palais Royal) (Musée des Beaux-Arts, Angers, France)

Painter │ watercolor landscapes │ *Landscape,* from *A New Method of Assisting the Invention in Drawing Original Compositions of Landscape,* 1784-86 (The Metropolitan Museum of Art, NYC)

Sculptor │ industrial objects in his works │ *Eroded Landscape,* 1992 (Lisson Gallery, London, England)

C NAME • **(PRONUNCIATION)** • Nationality • (dates)

CRANACH, Lucas the Elder **(KRAH-nahk)**
German (1472–1553)

CREDI, Lorenzo di **(KRAY-dee)**
Italian (1459–1537)

CRESPI, Giuseppe Maria **(KRES-pee)**
Italian/Bolognese (1665–1747)

CRIVELLI, Carlo **(kree-VEL-lee)**
Italian/Venetian (c. 1430–1495)

CROPSEY, Jasper Francis **(KROP-see)**
American (1823–1900)

FAST FACTS

Renaissance painter | religious and mythological subjects | portraits | *Cupid Complaining to Venus,* c. 1530 (The National Gallery, London, England)

Painter | pupil and friend of Leonardo da Vinci | painted *The Holy Family* (examples in The National Gallery, London, England and Musée du Louvre, Paris, France)

Painter | altarpieces and religious subjects | *Cupids with Sleeping Nymphs,* c. 1700 (National Gallery of Art, Washington, DC)

Religious painter | *Saint George and the Dragon* (Isabella Stewart Gardner Museum, Boston)

Painter | Hudson River School | *Autumn Landscape on the Hudson River,* 1876 (The White House, Washington, DC)

CUNNINGHAM, Imogen **(KUN-ing-ham)**
American *f* (1883–1976)

CURRY, John Steuart **(KUH-ree)**
American (1897–1946)

CUYP, Aelbert **(KOYP)**
Dutch (1620–1691)

NOTES:

FAST FACTS

Photographer | *Leaf Pattern,* before 1929 (The Museum of Modern Art, NYC)

Painter, muralist | scenes of rural Midwestern life | *Tornado Over Kansas* | *Baptism in Kansas,* 1928 (Whitney Museum of American Art, NYC)

Painter | Dutch School | *Herdsmen with Cows by a River,* c. 1650 (The National Gallery, London, England)

DA VINCI, Leonardo **(duh VIN-chee)**
Italian/Florentine (1452–1519)

DAGUERRE, Louis-Jacques-Mandé **(duh-GAYR)**
French (1787–1851)

DAHL-WOLFE, Louise **(DAHL-WOOLF)**
American f (1895–1989)

DALÍ, Salvador **(DAH-lee)**
Spanish (1904–1989)

Painter, sculptor, architect, designer, geologist, scientist, inventor, musician, and art critic | one of the greatest artists of the Italian Renaissance | *Mona Lisa, (La Gioconda)* c. 1503 (Musée du Louvre, Paris, France) | *Ginevra de' Benci,* 1474 (National Gallery of Art, Washingon, DC)

Painter, inventor of the Daguerreotype process of making permanent photographic pictures | created the "diorama"

Photographer | worked for *Harper's Bazaar* magazine

Surrealist painter, designer of jewelry and stage sets, book illustrator, writer | *The Persistence of Memory,* 1931 (The Museum of Modern Art, NYC)

DALLIN, Cyrus **(DAL-in)**
American (1861–1944)

DAUBIGNY, Charles-François **(doe-bin-YEE)**
French (1817–1878)

DAUMIER, Honoré **(doe-mee-yay)**
French (1808–1879)

DAVID, Gerard **(DAY-vid)**
Flemish (1450/60–1523)

FAST FACTS

Sculptor | Native American themes and heroic equestrian statues | *Appeal to the Great Spirit,* 1909 (at the Huntington Ave. entrance to the Museum of Fine Arts, Boston, Massachusetts)

Painter, printmaker | landscape artist of the Barbizon School | worked on his floating atelier along the Seine and Oise Rivers | *Spring* and *Great Valley of Optevoz,* both 1857 (both at Musée du Louvre, Paris, France)

Painter, caricaturist, graphic artist, sculptor, lithographer | *Advice to a Young Artist* (probably after 1860) (National Gallery of Art, Washington, DC)

Landscape painter | *The Virgin Among Virgins,* 1511 (Musée des Beaux-Arts, Rouen, France)

D NAME • **(PRONUNCIATION)** • Nationality • (dates)

DAVID, Jacques-Louis **(dah-VEED)**
French (1748–1825)

DAVIS, Stuart **(DAY-vis)**
American (1894–1964)

DEGAS, Edgar **(deh-GAH)**
French (1834–1917)

DELACROIX, Eugène **(deh-lah-kwah)**
French (1798–1863)

DELAUNAY, Robert **(deh-loe-nay)**
French (1885–1941)

FAST FACTS

Neo-classical painter | much of his work represents the
sentiments of the French Revolution | *The Death of Marat*,
1793 <small>(Les Musées Royaux des Beaux-Arts, Brussels, Belgium)</small>

Painter, illustrator, graphic artist | The Ashcan School |
Lucky Strike, 1921 <small>(The Museum of Modern Art, NYC)</small>

Impressionist painter, pastelist, sculptor | ballerinas |
Dance Class, c. 1874 <small>(Musée d'Orsay, Paris France)</small>

Romantic painter, draftsman, lithographer, writer, art critic |
Liberty Leading the People, 1830 <small>(Musée du Louvre, Paris, France)</small>

Painter | inspired by the machine age | married to artist
Sonia Delaunay | *Homage to Blériot,* 1914 (first pilot to fly
across the English Channel) <small>(Musée de l'Art Moderne de la Ville de
Paris, Paris, France)</small>

DELAUNAY, Sonia Terk **(deh-loe-nay)**
Russian ƒ (b. Ukraine 1885–1979)

DELLA ROBBIA, Andrea **(del-luh ROE-bee-ah)**
Italian/Florentine (1435–1525)

DELLA ROBBIA, Luca **(del-luh ROE-bee-ah)**
Italian/Florentine (c. 1400–1482)

DELVAUX, Paul **(del-VOE)**
Belgian (b. 1897)

FAST FACTS

Painter, printmaker, costume designer (active in France) |
married to artist Robert Delaunay | *Couverture,* 1911 (Musée
National de l'Art Moderne, Paris, France)

Sculptor | continued work on the terra cotta glazing
process started by his uncle, artist Luca della Robbia

Sculptor | *Singing Gallery* (marble sculpture for the
Cathedral of Florence, Italy) | developed a family business
specializing in the terra-cotta glazing process during the
Renaissance

Surrealist painter | images of nude women and architec-
ture | *The Awakening of the Forest,* 1939 (The Art Institute of
Chicago, Chicago, Illinois)

DEMUTH, Charles **(duh-MOOTH)**
American (1883–1935)

DENIS, Maurice **(deh-NEE)**
French (1870–1943)

DERAIN, André **(duh-RA(N))**
French (1880–1954)

DESPIAU, Charles **(des-pee-yo)**
French (1874–1946)

FAST FACTS

Painter, illustrator │ flowers, city scenes, architectural subjects │ *I Saw the Figure 5 in Gold,* 1928 (The Metropolitan Museum of Art, NYC) │ *My Egypt,* 1927 (Whitney Museum of American Art, NYC)

Painter and art theorist │ one of the original group of Symbolist painters called the Nabis │ *Hommage à Cézanne,* 1900 (Musée d'Art Moderne, Paris, France)

Painter, illustrator │ member of the Fauves │ *Charing Cross Bridge,* 1906 (National Gallery of Art, Washington, DC) │ *The Pool of London,* 1906 (The Tate Gallery, London, England)

Sculptor, painter │ portrait sculptures │ worked with Auguste Rodin │ *Mrs. Charles Lindberg and Madame Derain*

DIEBENKORN, Richard **(DEE-ben-korn)**
American (b. 1922)

DINE, Jim **(DYNE)**
American (b. 1935)

DIX, Otto **(DIKS)**
German (1891–1969)

DOBSON, William **(DAHB-sun)**
British (1610–1646)

DOESBURG, Theo van **(DUZE-berg)**
Dutch (1883–1931)

FAST FACTS

Painter | prints and drawings | *Still Life: Cigarette Butts and Glasses,* 1967 (National Gallery of Art, Washington, DC)

Pop artist, sculptor, painter | participated in "Happenings" | *Double Isometric Self Portrait (Serape),* 1964 (Whitney Museum of American Art, NYC)

Painter, portraitist | associated with the Neue Sachlichkeit ("new objectivity") group | *The Match Seller,* 1920 (Staatsgalerie, Stuttgart, Germany)

Painter | portraits of the Royal officers of the Civil War | *Endymion Porter,* c. 1640–43 (The Tate Gallery, London, England)

Painter, sculptor, writer | taught at the Bauhaus | he and Mondrian founded *De Stijl* magazine with Piet Mondrian

D NAME • **(PRONUNCIATION)** • Nationality • (dates)

DOISNEAU, Robert **(dwa-NOE)**
French (b. 1912)

DOMENICHINO, (Domenico Zampieri) **(do-me-ni-KEE-noe)**
Italian (1581–1641)

DONALDSON, Anthony **(DAH-nuld-sun)**
British (b. 1939)

DONATELLO, (doh-nah-TEL-loe) Donao di Niccolo
Italian/Florentine (c. 1386–1466)

DONGEN, Kees van **(DAHN-gen)**
French (b. Holland 1877–1968)

DORÉ, Paul Gustave **(dor-RAY)**
French (1832–1883)

FAST FACTS

Photographer | Parisian scenes | *The Tableau in the Window of the Collector Romi,* 1949 (The Museum of Modern Art, NYC)

Painter | *Landscape with Tobias Laying Hold of the Fish,* c. 1617–18 (The National Gallery, London, England)

Painter, sculptor | *Girl on a Swing* (series of life-sized, nude female sculptures) mid 1980s (PC, Boston)

Early Italian Renaissance sculptor | *David,* 1428–32 (Museo Nazionale del Bargello, Florence, Italy)

Painter | *Woman in a Black Hat,* c. 1908 (The Hermitage, St. Petersburg, Russia)

Painter, Illustrator | known for his wood engravings | *Puss 'n Boots* | *L'Éigme,* 1871 (Musée d'Orsay, Paris, France)

DOSSI, Dosso **(DOHS-see)**
Italian/Ferrarese (1479–1542)

DOU, Gerard **(DOW)**
Dutch (1613–1675)

DOVE, Arthur **(DUHV)**
American (1880–1946)

DROUAIS, François-Hubert **(droo-ay)**
French (1727–1775)

DUBUFFET, Jean **(doo-booh-fay)**
French (1901–1985)

Painter | *Circe and Her Lovers in a Landscape,* c. 1525
(National Gallery of Art, Washington, DC)

Dutch school | genre and portraiture | pupil of
Rembrandt | *The Hermit,* 1670 (National Gallery of Art, Washington,
DC)

Painter, collagist | early abstract painter | painted court
women as mythological characters | *Me and the Moon,*
1937 (Phillips Collection, Washington, DC)

Rococo portrait painter | women and children | *Comte
and Chevalier de Choiseul,* 1756 (The Frick Collection, NYC)

Painter, printmaker, sculptor | developed "Art Brut" |
Beard of Uncertain Returns, 1959 (Museum of Modern Art, NYC)

DUCCIO DI BUONINSEGNA
(DOO-choe di bwo-nin-SAYN-ya)
Italian/Sienese (c. 1250–c. 1319)

DUCHAMP, Marcel **(doo-SHOHM)**
French (1887–1968)

DUCHAMP-VILLON, Raymond **(do-SHOHM vee-YOHN)**
French (1876–1918)

DUFY, Raoul **(doo-FEE)**
French (1877–1953)

DUNOYER DE SEGONZAC, André
(doo-nwy-ay di say-gohn-ZAK) French (1884–1974)

FAST FACTS

Early Renaissance painter | *Maestà,* altarpiece for the
Siena Cathedral, Italy, 1308-11 | *The Rucellai Madonna*
(after 1285) (Galleria degli Uffizi, Florence, Italy)

Cubist painter | *Nude Descending a Staircase, No. 2,* 1912
(The Philadelphia Museum of Art, Philadelphia, Pennsylvania)

Cubist sculptor, architect | sculpture series on horses |
The Horse, 1914 (The Museum of Modern Art, NYC)

Painter, textile designer | beach, yachting, and horse rac-
ing scenes | *Le Haras du Pin* (The Baltimore Museum of Art,
Baltimore, Maryland)

Painter, engraver | *Beaches,* a series of engravings pub-
lished in 1935

D NAME • **(PRONUNCIATION)** • Nationality • (dates)

DURAND, Asher Brown **(dur-RAND)**
American (1796–1886)

DÜRER, Albrecht **(DOOH-rer)**
German (1471–1528)

DUVENECK, Frank **(DOO-ven-eck)**
American (1848–1919)

DYCK, Anthony Van **(DYKE)**
Netherlandish (1599–1641)

NOTES:

Painter, engraver, illustrator | Biblical subjects, landscapes, portraits | *Kindred Spirits,* 1849 (New York Public Library, NYC)

Painter, engraver | known for woodcuts and engravings | *Self-Portrait*, 1498 and *Knight, Death, and the Devil* (engraving) (both Museo del Prado, Madrid, Spain)

Painter, printmaker, and teacher | *The Whistling Boy*

Painter | portraits | Flemish school | *Charles I of England Out Hunting,* c. 1635–38 (Musee du Louvre, Paris France)

EAKINS, Thomas **(AY-kinz)**
American (1844–1916)

EAMES, Charles **(EEMZ)**
American (1907–1978)

EARL, Ralph **(ERL)**
American (1751–1801)

EASTLAKE, Charles Lock **(EEST-lake)**
English (1793–1865)

EIFFEL, Alexandre Gustave **(ay-FEL)**
French (1832–1923)

Realist painter | outdoor life, sports, and portraits | *The Biglin Brothers Racing,* c. 1873 (National Gallery of Art, Washington, DC) | *The Gross Clinic,* 1875 (Jefferson Medical College, Philadelphia, Pennsylvania)

Architect, furniture designer | design for a molded-plywood chair, 1945–46 | "Lounge Chair," 1956

Portrait painter | interior group portraits | *Mrs. Richard Alsop*, 1792 (National Museum of American Art, Washington, DC)

Historical and genre painter | portraits of Napoleon Bonaparte | *Materials for the History of Oil Painting,* 1847

Architect | *The Eiffel Tower,* designed for the 1889 Exposition in Paris, France

ELLIOTT, Charles Loring **(EL-lee-yut)**
American (1812–1868)

ENSOR, James **(EN-sore)**
Belgian (1860–1949)

EPSTEIN, Jacob **(EP-stine)**
British (1880–1959)

ERNST, Max **(AIRNST)** German (1891–1976)

ERTÉ (AIR-tay) (Romain de Tirtoff)
Russian (1892–1990)

ESCHER, Maurits Cornelius (M.C.) **(EH-sher)**
Dutch (1898–1972)

FAST FACTS

Portrait painter │ scenes of New York City

Painter, printmaker │ *Woman in Blue,* 1881 (Museum of Modern Art, Brussels, Belgium)

Sculptor │ portrait busts of well-known people │ primativist style │ *The Rock–Drill,* 1913-14 (The Tate Gallery, London, England)

Surrealist │ Dadaist │ "insane art" │ *Two Children Are Threatened by a Nightingale,* 1924 (Museum of Modern Art, NYC)

Illustrator, costume designer for the theater │ fashion illustrations for *Harper's Bazar* covers, 1915-1926 (Bazaar since late1929)

Graphic artist, printmaker │ bizarre metamorphoses and optical illusions │ *Reptiles,* 1943 (The Hague, The Netherlands)

ESTES, Richard **(ES-teez)**
American (b. 1936)

EVANS, Walker **(EH-venz)**
American (1903–1975)

EYCK, Hubert van **(IKE)**
Flemish (c. 1370–1426)

EYCK, Jan van **(IKE)**
Flemish (1390–1441)

NOTES:

FAST FACTS

Painter | early experimenter in Photo-Realism |
Woolworth's, 1974 (San Antonio Museum Association, San Antonio, Texas)

Photographer | *Sharecropper and Family, Alabama,* 1939
(PC, NYC) | *Alabama Cotton Tenant Farmer's Wife,* 1936 (The
Art Institute of Chicago, Chicago, Illinois)

Painter | possibly started painting the *Ghent Altarpiece* |
brother of artist Jan van Eyck

Painter | *The Arnolfini Marriage,* 1434 (The National Gallery,
London, England) | *Ghent Altarpiece,* completed 1432 (St. Bauo,
Ghent, Belgium)

NAME • (PRONUNCIATION) • Nationality • (dates)

FABRITIUS, Carel **(fa-BREET-see-yus)**
Dutch (1622–1654)

FALGUIÈRE, Jean-Alexandre-Joseph **(fal-gee-AIR)**
French (1831–1900)

FANTIN-LATOUR, Henri **(fan-tan lah-TOOR)**
French (1836–1904)

FATTORI, Giovanni **(fat-TOHR-ree)**
Italian (1825–1908)

FEININGER, Andreas **(FY-nin-ger)**
American (b. France 1906)

FAST FACTS

Painter | portraits and religious subjects | studied with Rembrandt | *The Sentinel,* 1654 (Staatliches Museum, Schwerin, Germany)

Sculptor | worked in bronze and marble | *Victor Hugo* (Théâtre Français, Paris, France)

Painter, lithographer | flower painter | *A Studio in the Batignolles Quarter,* 1870 (depicts Manet in his studio) (Musée d'Orsay, Paris, France)

Painter | member of the Macchiaioli | military subjects | *Rest,* c.1885–87 (Pinacoteca di Brera, Milan, Italy)

Photographer | *The Photojournalist*

FEININGER, Lyonel **(FY-nin-ger)** American (1871–1956)

FEKE, Robert **(FEEK)**
American (1707–1752)

FEUERBACH, Anselm **(FOY-er-bahk)**
German (1829–1880)

FISCHL, Eric **(FISH-ull)** American (b. 1948)

FLAVIN, Dan **(FLAY-vin)** American (b. 1933)

FAST FACTS

Painter, graphic artist, cartoonist, wood engraver | founded the Blaue Vier with Paul Klee, Wassily Kandinsky, and Alexey von Jawlensky | comic-strips | *Viaduct,* 1920 (The Museum of Modern Art, NYC)

Painter | colonial portraits | *Thomas Hopkinson,* 1746 (National Museum of American Art, Washington, DC)

Romantic painter | portraits, landscapes, historical paintings | *Woman Playing a Mandolin,* 1865 (Hamburg Museum, Hamburg, Germany)

Painter | Neo-Expressionist | *The Birthday Boy,* 1983

Neon light sculptor | "Electric Light Icons," 1961 (PC)

 NAME • (PRONUNCIATION) • Nationality • (dates)

FORAIN, Jean-Louis **(for-RA(N))**
French (1852–1931)

FORTUNY, Mariano **(for-TOO-nee)**
Italian (b. Spain 1838–1874)

FOUJITA, Tsuguharu **(foo-jee-tuh)**
Japanese (1886–1968)

FOUQUET, Jean **(foo-KAY)**
French (c. 1420–c. 1480)

FOX TALBOT, William Henry **(FOKS TAL-but)**
British (1800–1877)

Painter, graphic artist, newspaper caricaturist | *The Race Track,* c. 1891 (National Gallery of Art, Washington, DC)

Painter | clothing designer known for his pleating techniques and metallic printing processes | lived and worked in Venice

Painter | lived in Paris | *Young Girl in the Park,* 1957 (PC)

Painter | *Étienne Chevalier and Saint Stephen,* c. 1450 (Staatliche Museen, Berlin-Dahlem, Germany)

Photographer | announced method of making photographs to the public in 1839 | *Latticed Window at Lacock Abbey,* 1835 (Fox Talbot Collection, Science Museum, London, England)

FRAGONARD, Jean-Honoré **(frag-oh-NAHR)**
French (1732–1806)

FRANCESCO DI GIORGIO (fran-CHESS-koe di JOR-jo)
Italian (1439–1502)

FRANCIS, Sam **(FRAN-sis)**
American (b. 1923)

FRANK, Robert **(FRANK)**
American (b. 1924)

FRANKENTHALER, Helen **(FRAN-ken-thall-er)**
American *f* (b. 1928)

FAST FACTS

Rococo painter | portraits, history paintings, picnics, fêtes
| *Blind Man's Buff,* c. 1765 (National Gallery of Art, Washington, DC)
| *The Swing,* 1768–69 (The Wallace Collection, London, England)

Architect, sculptor, painter | designed the bronze tabernacles above the high altar of the Cathedral in Florence, Italy

Painter | abstract expressionist | watercolors | *Around the Blues,* 1957–62 (The Tate Gallery, London, England)

Photographer | *Drug Store—Detroit*, 1955 (National Gallery of Art, Washington, DC)

Painter | abstract expressionist | married to artist Robert Motherwell | *Mountains and Sea,* 1952 (Collection of the Artist at the National Gallery of Art, Washington, DC)

FRENCH, Daniel Chester **(FRENCH)**
American (1850–1931)

FREUD, Lucian **(FROYD)**
German (b. 1922)

FRIEDLANDER, Lee **(FREED-lan-der)**
American (b. 1934)

FRIEDRICH, Caspar David **(FREED-rihk)**
German (1774–1840)

FRINK, Dame Elisabeth **(FRINK)**
British *f* (1930–1993)

FAST FACTS

Sculptor | *Abraham Lincoln,* 1922 (marble) (The Lincoln Memorial, Washington, DC)

Superrealist painter | grandson of Dr. Sigmund Freud | *Girl with a White Dog,* 1951 (The Tate Gallery, London, England)

Photographer | first exhibited with photographers Garry Winogrand and Diane Arbus | *Mount Rushmore, South Dakota,* 1969 (Philadelphjia Museum of Art, Philadelphia, Pennsylvania)

Landscape painter | Romantic style | *Moonrise Over the Sea,* 1822 (Staatliche Museen, West Berlin, Germany)

Neo-Expressionist painter | *Goggle Head,* 1969 (Beaux-Arts Gallery, London, England)

FRISSEL, Toni **(fri-SEL)**
American *f* (1907–1988)

FROMENT, Nicolas **(fro-MOHN)**
French (1450–1490)

FUSELI, Henry **(FYOO-zeh-lee)**
Swiss (1741–1825)

NOTES:

FAST FACTS

Photographer | photos for *Vogue* and *Harper's Bazaar* magazines | *Spring of the Mermaid,* 1947 (Library of Congress, Washington, DC)

Provencal painter | portraitist | triptych in the Cathedral of Aix-en-Provençe in France

Romantic painter | themes of horror and eroticism | active in England | *The Nightmare,* 1781 (The Detroit Institute of the Arts, Detroit, Michigan)

GABO, Naum **(GAH-boe)**
American (b. Russia 1890–1977)

GADDI, Agnolo **(GAHD-dee)**
Italian/Florentine (1350–1396)

GADDI, Gaddo **(GAHD-dee)**
Italian/Florentine (c. 1260–1333)

GADDI, Taddeo **(GAHD-dee)**
Italian/Florentine (c. 1300–1366)

FAST FACTS

Constructivist sculptor and designer | kinetic sculpture | known for nonfigurative geometrical constructions | *Head of a Woman,* c. 1917–20 (The Museum of Modern Art, NYC)

Painter | son of the artist Taddeo Gaddi | *Madonna Enthroned with Saints and Angels*

Painter and mosaicist | notable work in mosaic on the chief portal of the Florence Cathedral in Italy

Painter and architect | son of Gaddo Gaddi | pupil of Giotto | frescoes of the life of Mary in the Church of Santa Croce in Florence, Italy

GAINSBOROUGH, Thomas **(GAYNZ-buh-roe)**
British (1727–1788)

GAUDI, Antonio **(gow-DEE)**
Spanish (1852–1926)

GAUDIER-BRZESKA, Henri **(goe-dee-ay BZHES-kuh)**
French (1891–1915)

GAUGUIN, Paul **(go-GA(N))**
French (1848–1903)

GAVARNI, Paul **(ga-vahr-NEE)**
French (1804–1866)

FAST FACTS

Portrait painter | *Blue Boy,* c.1770 (The Huntington Art Collections, San Marino, California)

Architect, designer | Art Nouveau style | organic forms | *Casa Milá Apartment House*, 1905–07 (Barcelona, Spain)

Sculptor | Vorticist | animal sculptures and figure groups | *Birds Erect,* 1914 (The Museum of Modern Art, NYC)

Painter, sculptor | pioneer of Post-Impressionism | painted in Tahiti | *Where do we come from? Who are we? Where are we going?,* 1897 (Museum of Fine Arts, Boston) | *The Farm at La Pouldu,* 1890 (Dallas Museum of Art, Dallas, Texas)

Draftsman, book illustrator, caricaturist | illustrations for *Le Charivari* magazine

NAME • (PRONUNCIATION) • Nationality • (dates)

GELÉE, Claude or Claude Lorrain **(zhel-LAY)**
French (1600–1682)

GENTILE DA FABIANO
(jen-TEE-lay duh fah-bree-AH-noe)
Italian (c. 1370–1427)

GENTILESCHI, Artemisia **(jen-ti-LES-kee)**
Italian *f* (1593–c. 1653)

GENTILESCHI, Orazio **(jen-ti-LES-kee)**
Italian (1563–1639)

Painter | helped to establish the tradition of landscape painting in Europe | *Landscape with Ascanius Shooting the Stag of Silvia,* 1682 (National Gallery of Art, Washington, DC)

Painter of the Umbrian school | studied under Fra Angelico | *The Adoration of the Magi,* 1423 (Galleria degli Uffizi, Florence, Italy)

Painter | one of the first female painters whose work can be attributed to her | influenced by Caravaggio | *Martha Upbraids Her Sister Mary,* c,1650 (The Alte Pinakothek, Munich Germany)

Painter | father of artist Artemisia Gentileschi | *The Lute Player,* c. 1610 (National Gallery of Art, Washington, DC)

GÉRICAULT, Théodore **(zhe-ree-COE)**
French (1791–1824)

GÉRÔME, Jean Léon **(zhe-ROME)**
French (1824–1904)

GHIBERTI, Lorenzo **(gee-BEAR-tee)**
Italian (1378–1455)

GHIRLANDAIO, Domenico **(geer-lan-DYE-oh)**
Italian/Florentine (1449–1494)

Painter, sculptor | studies of horses, mental illness, and historic events | forerunner of the break with classicism | advanced the development of romanticism | *The Raft of the Medusa,* 1819 (Musée du Louvre, Paris, France)

Painter, sculptor | *Pygmalion and Galatea,* after 1881 (The Metropolitan Museum of Art, NYC)

Sculptor and goldsmith | designed the cast bronze doors on the Baptistry in Florence, Italy (1404-24; and 1425-52 called "Gates of Paradise")

Painter, mosaicist | a teacher of Michelangelo | *An Old Man and his Grandson,* c. 1480 (Musée du Louvre, Paris, France)

GIACOMETTI, Alberto **(jok-oh-MET-tee)**
Italian (1901–1966)

GIAMBOLOGNA (jahm-boe-LONE-yuh)
(Giovanni Bologna) Italian (1529–1608)

GIBRAN, Kahlil **(ji-BRAHN)** Lebanese (1883–1931)

GIBSON, Charles Dana **(GIB-sun)** American (1887–1944)

GIFFORD, Sanford Robinson **(GIF-erd)**
American (1823–1880)

GIORDANO, Luca **(jor-DAH-noe)**
Italian (1632–1705)

FAST FACTS

Surrealist sculptor, painter | known for thin, elongated, wiry figures | *Walking Man II,* 1960 (National Gallery of Art, Washington, DC)

Mannerist sculptor | *The Rape of the Sabine Women,* 1579–83 (Loggia dei Lanzi, Florence, Italy)

Painter | writer of *The Prophet,* 1923

Illustrator | creator of the "Gibson Girl" style, early 1900s

Painter | Hudson River School | dramatic landscapes | *October in the Catskills*

Baroque painter | ceilings, altarpieces, frescoes | called "Fa-Presto" for painting swiftly | *Venus, Cupid and Mars,* n.d. (Museo di Capodimonte, Naples, Italy)

GIORGIONE (jor-JOE-nay) (Giorgione da Castelfranco)
Venetian (1478–1510)

GIOTTO DI BONDONE (JOHT-toe di bohn-DOE-nay)
Italian (c. 1266–1337)

GIOVANNI DI PAOLO (joe-VAH-nee di POW-loe)
Italian/Sienese (1403–1482)

GIRARDON, François **(zheer-ahr-DOHN)**
French (1628–1715)

GIULIO ROMANO (JOOL-yo roe-MAH-noe)
Italian (1492–1546)

FAST FACTS

Painter | *The Tempest,* c. 1500 (Galleria dell'Accademia, Venice, Italy)

Religious painter, architect | frescoes and altarpieces | *The Lamentation,* c. 1305 (The Arena Chapel, Padua, Italy)

Painter | *The Expulsion from Paradise* (The Metropolitan Museum of Art, Cloisters, NYC)

Sculptor | *Model for Equestrian Statue of Louis XIV,* c. 1687 (Yale University Art Gallery, New Haven, Connecticut)

Baroque painter, architect | pupil of Raphael | *The Fall of the Giants,* 1532-34 (Palazzo del Té, Mantua, Italy)

GLACKENS, William James **(GLA-kins)**
American (1870–1938)

GLEIZES, Albert **(GLEZ)**
French (1881–1953)

GLEYRE, Charles **(GLARE)**
Swiss (1806–1874)

GOERITZ, Mathias **(GER-itz)** German (b.1915)

GOES, Hugo van der **(GOOS)**
Flemish (c. 1440–1482)

FAST FACTS

Painter and illustrator | an original member of the Ashcan School and "The Eight" | *Hammerstein's Roof Garden,* c. 1901 (Whitney Museum of Art, NYC)

Designer and Cubist painter | *Harvest Threshing,* 1912 (The Solomon R. Guggenheim Museum, NYC)

Painter, writer | active in France | taught Claude Monet, Pierre-Auguste Renoir, and Alfred Sisley | genre themes

Sculptor | worked in Mexico City | *Steel Structure,* 1952-53 (The Echo, Mexico City, Mexico)

Painter | large scale works | pupil of Jan van Eyck | *The Adoration of the Shepherds* (from The Portinari Altarpiece), 1474–76 (Galleria degli Uffizi, Florence, Italy)

GOGH, Vincent Van **(GOE)** or **(GUHK)**
Dutch (1853–1890)

GOLTZIUS, Hendrick **(GOLE-tze-us)** Dutch (1558–1617)

GORKY, Arshile **(GOR-kee)**
American (1904–1948)

GOSSAERT, Jan **(goe-SAHRT)** (Mabuse)
Netherlandish (c. 1478–1533)

GOTTLIEB, Adolf **(GOT-leeb)**
American (b. Turkish Armenia 1903–1974)

GOYA, Francisco **(GOY-uh)**
Spanish (1746–1828)

FAST FACTS

Painter | self-portraits and sunflowers | *The Starry Night,* 1889 (The Museum of Modern Art, NYC)

Painter | *Venus and Adonis* (Alte Pinakothek, Munich, Germany)

Painter | leading member of the abstract expressionist movement | *Agony,* 1947 (The Museum of Modern Art, NYC)

Painter | *Neptune and Amphitrite,* c. 1516 (Staatliche Museen, Berlin-Dahlem, Germany)

Sculptor, painter | *Wall,* 1968 (National Gallery of Art, Washington, DC)

Painter, portraitist, graphic artist | Spanish life, religious scenes, "black paintings" | Court painter | *The Third of May, 1808,* 1814–15 (Museo del Prado, Madrid, Spain)

NAME • **(PRONUNCIATION)** • Nationality • (dates)

GOYEN, Jan Van **(GOY-en)**
Dutch (1596–1656)

GRAVES, Nancy **(GRAVES)**
American f (1940–1995)

GRECO, EL (GRE-koe) (Domenikos Theotokopoulos)
Spanish (b. Crete 1541–1614)

GREENAWAY, "Kate", Catherine **(GREEN-uh-way)**
English f (1846–1901)

GREENOUGH, Horatio **(GREE-noe)**
American (1805–1852)

GREUZE, Jean-Baptiste **(GREUZ)**
French (1725–1805)

Painter │ specialized in landscapes of the Netherlands │ tonal style │ *Fort on a River,* 1644 (Museum of Fine Arts, Boston)

Sculptor, painter │ *Cantileve,* 1983 (Whitney Museum of Art, NYC) *Canoptic Legerdemain,* 1990 (National Gallery of Art, Washington, DC)

Painter │ religious works and visionary landscapes │ *Laocoön,* c. 1610 (National Gallery of Art, Washington, DC)

Ilustrator and writer of children's books │ watercolor │ *Under the Window,* 1879 │ *Marigold Garden,* 1885

Sculptor and writer │ colossal statue of George Washington as Zeus (Smithsonian Institution, Washington, DC)

Portrait painter │ genre │ *The Father's Curse,* n.d. (Musée du Louvre, Paris, France)

GRIMSHAW, Atkinson **(GRIM-shaw)**
British (1836–1893)

GRIS, Juan **(GREECE)**
Spanish (1887–1927)

GROOMS, Red **(GROOMZ)**
American (b. 1937)

GROPIUS, Walter **(GRO-pee-us)**
German (1883–1969)

GROS, Antoine Jean, **(GROE)**
French (1771–1835)

FAST FACTS

Painter | *Nightfall Down the Thames,* 1880 (Leeds City Art Gallery, Leeds, England)

Painter | early collagist | a leader of the Cubist movment with Picasso and Braque | *The Wash-Stand,* (PC, Paris, France)

Painter, sculptor | theatrical environments | Happening: *Burning Building,* 1962

Architect | founder of the Bauhaus school in Weimar, Germany | *Shop Block,* 1925–26 (The Bauhaus, Dessau, Germany)

Historical painter | battle paintings | Romanicism | exhibited at the Paris salons, 1797–1835 | *Napoleon at Arcole,* 1796 (Musée du Louvre, Paris, France)

GROSZ, George **(GROSS)**
American (b. Germany 1893–1958)

GRÜNEWALD, Matthias **(GROO-ne-vahld)**
German (c. 1480–1528)

GUARDI, Francesco **(GWAHR-dee)**
Italian/Venetian (1712–1793)

GUERCINO, Giovanni Francesco Barbieri **(gwer-CHEE-noe)**
Italian/Bolognese (1591–1666)

GUÉRIN, Pierre Narcisse **(ger-RA(N))**
French (1774–1833)

FAST FACTS

Expressionist painter, graphic artist, caricaturist │ Dadaist │ known for his satires of war and society │ *The Engineer Heartfield,* 1920 (The Museum of Modern Art, NYC)

Renaissance painter │ *The Crucifixion* , from The Isenheim Altarpiece, c. 1510–15 (Musée d'Unterlinden, Colmar, France)

Painter │ known for his scenes of Venice │ *View on the Cannareggio, Venice,* c. 1770 (National Gallery of Art, Washington, DC)

Painter │ *Saint Francis in Ecstasy and Saint Benedict* (Musée du Louvre, Paris, France)

Historical painter │ Neoclassical │ taught Théodore Géricault and Eugène Delacroix

GUIMARD, Hector **(gee-MAHR)**
French (1867–1942)

GUSTON, Philip **(GOOH-stun)**
American (1913–1980)

GUYS, Constantin **(GEEZ)**
French (1805–1892)

NOTES:

Architect | known for his cast iron Art Nouveau Paris Métro entrances, early 1900s

Painter | Abstract Expressionist | figurative imagery | *Painter's Table,* 1973 (National Gallery of Art, Washington, DC)

Painter, illustrator, draftsman | drawings of Parisian society | *Two Ladies with Muffs,* c. 1875–80 (Courthauld Institute Galleries, London, England)

HALS, Franz **(HALCE)**
Dutch (1580–1666)

HAMILTON, Richard **(HAM-il-tun)**
British (b. 1922)

HANSON, Duane **(HAN-sun)**
American (b. 1928)

HARDING, Chester **(HAHR-ding)**
American (1792–1866)

HARING, Keith **(HER-ing)**
American (1958–1990)

Portrait and genre painter │ *The Laughing Cavalier,* 1624
(The Wallace Collection, London, England)

Painter │ early English Pop artist │ *Just What is it That Makes Today's Home So Different, So Appealing? 1956*
(Kunsthalle, Tübingen, Germany)

Sculptor │ lifelike figures made of polyester resin and fiberglass │ *Woman with Dog,* 1977 (Whitney Museum of American Art, NYC)

Portrait painter │ painted Daniel Webster │ rival of Gilbert Stuart

Pop artist │ graffiti style posters │ popularly known for his Swatch™ watch designs

HARNETT, William **(HAHR-net)**
American (1848–1892)

HARTIGAN, Grace **(HAHR-ti-gen)**
American f (b. 1922)

HARTLEY, Marsden **(HAHRT-lee)**
American (1877–1943)

HARTUNG, Hans **(HAHR-toong)**
French (b. Germany 1904–1989)

HARUNOBU, Suzuki **(ha-roo-NOE-boo)**
Japanese (1724–1770)

FAST FACTS

Still life painter, illusionist | *After the Hunt,* 1885 (California Palace of the Legion of Honor, San Francisco, California)

Abstract Expressionist painter | *Grand Street Brides,* 1954 (Whitney Museum of American Art, NYC)

Abstract painter | scenes of Maine's coastline | *Movements,* 1915 (The Art Institute of Chicago, Chicago, Illinois)

Abstract painter | non-representational artist | incorporated calligraphic brushstrokes in his paintings | *T 1955-23,* 1955 (Collection of the artist)

Painter and printmaker | Ukiyo-e master | polychromatic woodblock prints | *Young Woman in a Summer Shower,* 1765 (The Art Institute of Chicago, Chicago, Illinois)

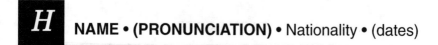

HASSAM, Childe **(HAS-sem)**
American (1859–1935)

HAUSSMAN, George Eugène **(OHS-mahn)**
French (1809–1891)

HAYTER, Stanley William **(HAY-ter)**
British (1901–1988)

HEADE, Martin Johnson **(HEED)**
American (1819–1904)

HEALY, George Peter Alexander **(HEE-lee)**
American (1813–1894)

Impressionist painter | important member of the "Ten American Painters" group | *The Avenue in Rain,* 1917 (The White House, Washington, DC)

Architect, urban planner | designed the Boulevard Haussman in Paris, France

Painter, engraver | early member of the Surrealist movement | published *New Ways of Gravure About Prints*

Painter, luminist | *Orchids and Spray Orchids with Hummingbirds,* 1865 (Museum of Fine Arts, Boston)

Portrait painter | *Daniel Webster,* 1852 (Pennsylvania Academy of the Fine Arts, Philadelphia, Pennsylvania)

HECKEL, Erich **(HEK-el)**
German (1883–1970)

HEEM, Jan Davidsz de **(HAME)**
Dutch (c. 1606–1684)

HELLEU, Paul **(eh-LEU)**
French (1859–1927)

HENRI, Robert **(HEN-rye)**
American (1865–1929)

HEPWORTH, Barbara **(HEP-werth)**
British *f* (1903–1975)

FAST FACTS

Painter, printmaker | lithographs, woodcuts | founder of the Expressionist school called Die Brücke, c. 1905

Still-life painter | *Flower Still Life,* c. 1665 (Ashmolean Museum, Oxford, England)

Painter, draftsman | society portraits

Painter, teacher, critic | leader of the Ashcan School | *Blind Spanish Singer,* 1912 (National Museum of American Art, Washington, DC)

Sculptor | organic, abstract forms | pierced shapes | worked in wood, marble, bronze | *Three Forms,* 1935 (The Tate Gallery London, England)

HERKOMER, Hubert von **(HER-kuh-mer)**
British (b. Germany 1849–1914)

HERRERA, Juan de **(er-RARE-uh)**
Spanish (1530–1597)

HESSE, Eva **(HES-suh)**
American f (b. Germany 1936–1970)

HEYDEN, Jan van der **(HIE-den)**
Dutch (1637–1712)

HICKS, Edward **(HIKS)**
American (1780–1849)

FAST FACTS

Portrait painter, printmaker, film pioneer, engineer | advocate of "color music"

Architect | *The Escorial,* c. 1563–84 (near Madrid, Spain)

Painter and sculptor | organic forms in fiberglass, latex, acrylic | *Accession II,* 1967 (The Detroit Institute of the Arts, Detroit, Michigan)

Painter, printmaker | known for his townscapes of Amsterdam

Painter, Quaker preacher | *The Peaceable Kingdom,* c. 1848 (Brooklyn Museum, Brooklyn, New York) | *Noah's Ark,* 1846 (Philadelphia Museum of Art, Philadelphia, Pennsylvania)

HILLIARD, Nicholas **(HIL-yerd)**
British (1547–1619)

HINE, Lewis Wickes **(HINE)**
American (1874–1940)

HIROSHIGE, Ando **(he-roe-SHEE-guh)**
Japanese (1797–1858)

HIRSHFIELD, Albert **(HERSH-feeld)**
American (b. 1903)

HOBBEMA, Meindert **(HOB-bih-muh)**
Dutch (1638–1709)

FAST FACTS

Painter, miniaturist | *Portrait of an Unknown Man*, c. 1588
(The Victoria and Albert Museum, London, England)

Photographer | portraits of the working class poor, espe-
cially children | *Breaker Boys,* 1911 (International Museum of
Photography at the George Eastman House, Rochester, New York)

Painter | Ukiyo-e school | color prints | *Thirty-Six Views
of Mount Fuji,* published by Tsutakichi, 1858 (PC)

Caricaturist | worked for *The New York Times* newspaper

Painter | landscapes | pupil of Jacob van Ruisdael | *The
Avenue, Middelharnis,* 1689 (The National Gallery, London, England)

HÖCH, Hannah **(HOHK)**
German *f* (1889–1979)

HOCKNEY, David **(HAHK-nee)**
British (b. 1937)

HODGKIN, Howard **(HODJ-kin)** British (b. 1932)

HODLER, Ferdinand **(HAHD-ler)**
Swiss (1853–1918)

HOFFMANN, Hans **(HOFF-mahn)**
American (b. Germany 1880–1966)

Collagist | Dadaist | reflected social tensions in the post-WWI era | *Cut with the Kitchen Knife,* 1919 (Staatliche Museen, Berlin, Germany)

Painter, photographer, printmaker | photomontage | *A Bigger Splash,* 1967 (The Tate Gallery, London, England)

Painter | scenes of daily life | *Lovers,* 1984–89 (PC)

Painter | symbolist | *Night,* 1889–90 (Kunstmuseum, Bern, Switzerland)

Painter, teacher | abstract drip paintings | *Fantasia,* 1943 (University Art Museum, Berkeley, California)

HOGARTH, William **(HOE-garth)**
British (1697–1764)

HOKUSAI, Katsushika **(hoe-koo-sy)**
Japanese (1760–1849)

HOLBEIN, Hans, the Elder **(HOLE-bine)**
German (1465–1524)

HOLBEIN, Hans, the Younger **(HOLE-bine)**
German (1497–1543)

HOLZER, Jenny **(HOLT-zer)**
American f (b. 1950)

FAST FACTS

Painter, printmaker | narrative, satirical style | *The Orgy, Scene III* from *The Rake's Progress,* c. 1734 (Sir John Soane's Museum, London, England) |

Painter, graphic artist | woodblock prints | *The Great Wave off Kanagawa,* from the series *Thirty-Six Views of Mount Fuji,* c. 1831 (The Art Institute of Chicago, Chicago, Illinois)

Painter | *Madonna of Burgomaster Meyer,* 1526 (Schlossmuseum, Darmstadt, Germany)

Portrait painter | *Edward VI as a Child,* c. 1538 (National Gallery of Art, Washington, DC)

Postmodernist conceptual artist | billboards, computerized moving signs | *Selection of Truisms,* 1982 (Times Square, NYC)

HOMER, Winslow **(HOE-mer)**
American (1836–1910)

HONTHORST, Gerrit van **(HAHNT-horst)**
Dutch (1590–1656)

HOOCH, Pieter de **(HOHK)**
Dutch (1629–1684)

HOPPER, Edward **(HAH-per)** American (1882–1967)

HOPPNER, John **(HAHP-ner)**
British (1758–1810)

FAST FACTS

Painter | landscapes, seascapes, everyday life |
Breezing Up, 1876 (National Gallery of Art, Washington,DC)

Painter | known for night scenes with candlelight settings
| *The Banquet,* 1620 (Palazzo Pitti, Florence, Italy)

Painter | genre paintings of everyday life | *The Courtyard
of a House in Delft,* 1658 (The National Gallery, London, England)

Painter | urban and rural American scenes | *Nighthawks,*
1942 (The Art Institute of Chicago, Chicago, Illinois) | *Conference at
Night,* 1949 (Wichita Art Museum, Wichita, Kansas)

Portrait painter | *Lady Harriet Cunliffe,* 1781-82 (National
Gallery of Art, Washington, DC)

HOUDON, Jean-Antoine **(OO-doh(n))**
French (1741–1828)

HUNT, William Holman **(HUNT)**
British (1827–1910)

HUNT, William Morris **(HUNT)**
American (1824–1879)

NOTES:

Sculptor | portraits | *Voltaire,* 1778 (National Gallery of Art, Washington, DC)

Painter | founded the Pre-Raphaelite Brotherhood in 1848 with John Everett Millais and Dante Gabriel Rossetti | *On English Coasts,* 1852 (The Tate Gallery, London, England)

Painter, teacher, landscape artist of the Barbizon school

INDIANA, Robert **(in-dee-AN-uh)**
American (b. 1928)

INGRES, Jean-Auguste-Dominique **(AN-gr(uh))**
French (1780–1867)

INNESS, George **(IN-nes)**
American (1825–1894)

IVANOV, Alexander **(ee-VAN-off)**
Russian (1806–1858)

NOTES:

Painter, sculptor | called the "American Painter of Signs" | *The Figure Five,* 1963 (National Museum of American Art) | *Love,* 1966 (Indianapolis Museum of Art, Indianapolis, Indiana)

Painter | portraits | female nudes in Oriental settings | *The Grand Odalisque,* 1814 (Musée du Louvre, Paris, France)

Painter | landscapes | *Lackawanna Valley,* 1855 (National Gallery of Art, Washington, DC) | *Autumn Gold* (Wadsworth Atheneum, Hartford, Connecticut)

Painter | religious subjects | *The Appearance of Christ to the People,* 1837–57 (Tretyakov Gallery, Moscow, Russia)

JACKSON, William Henry **(JAK-sun)**
American (1843–1942)

JAWLENSKY, Alexey von **(yo-VLEN-skee)**
German (b. Russia 1864–1941)

JOHN, Gwen **(JAHN)**
Welsh *f* (1876–1939)

JOHN, Augustus **(JAHN)**
British (1878–1961)

JOHNS, Jasper **(JAHNZ)**
American (b. 1930)

FAST FACTS

Photographer | scenes of the Old West | *The Grand Canyon of Yellowstone,* 1871

Expressionist painter | *Looking Within–Night, 1923*
(Philadelphia Museum of Art, Philadelphia, Pennsylvania)

Painter | Auguste Rodin's studio model and mistress | *Girl with Bare Shoulders,* c. 1910 (The Museum of Modern Art, NYC)

Painter | portraits | brother of artist Gwen John | *The Smiling Woman,* 1910 (The Tate Gallery, London, England)

Painter, sculptor, Pop artist | *Three Flags,* 1958 (Whitney Museum of American Art, NYC) | *The Critic Smiles,* published 1969 (National Gallery of Art, Washington, DC)

175

JOHNSON, Eastman **(JAHN-sun)**
American (1824–1906)

JOHNSTON, Joshua **(JAHN-stun)**
American (active 1789–1832)

JONES, Allen **(JONES)**
British (b. 1937)

JONGKIND, Johan Barthold **(YONG-kint)**
Dutch (1819–1891)

Portrait painter | genre scenes of the Western frontier, Native American Indians, and African-American Southern life | *Old Kentucky Home,* 1859 (The New York York Historical Society, NYC)

Painter | limner | portrayed the leading families of Maryland

Painter, sculptor, printmaker | early Pop artist | transformations, metamorphoses | *Hermaphrodite,* 1963 (Walker Art Gallery, Liverpool, England)

Painter | landscapes, watercolors | *The Quai d'Orsay,* 1852 (Musée Saliès, Bagnères-de-Bigorre, France)

NAME • **(PRONUNCIATION)** • Nationality • (dates)

JORDAENS, Jacobs **(YOR-dunz)**
Flemish (1593–1678)

JUDD, Donald **(JUD)**
American (b. 1928)

NOTES:

Portrait painter | tapestry designs | *The Four Evangelists,* c. 1617–18 (Musée du Louvre, Paris, France)

Minimalist sculptor | simple bold shapes that emphasize the relationship between the sculpture and the space around it | *Untitled,* 1965 (Leo Castelli Gallery, NYC)

KAHLO, Frida **(KAH-loe)**
Mexican f (1907–1954)

KANDINSKY, Wassily **(kan-DIN-skee)**
French (b. Russia 1866–1944)

KAPOOR, Anish **(kuh-POOR)**
Indian (b. 1954)

KÄSEBIER, Gertrude **(KAY-zi-beer)**
American f (1852–1934)

FAST FACTS

Painter | self-portraits | married to artist Diego Rivera | *The Broken Column,* 1944 (Collection of Dolores Olmedo, Mexico City, Mexico)

Painter | a pioneer of abstract art | member of Der Blaue Reiter | lively biomorphic forms | *Improvisation No. 30 (Cannons),* 1913 (The Art Institute of Chicago, Chicago, Illinois)

Sculptor | *It Is Man,* 1989 and *Untitled II Parts,* 1990 (Installation at the Centre National d'art Contemporain, Grenoble, Switzerland now at the Lisson Gallery, London, England)

Photographer | *Rodin,* 1905 (platinum print) (The Museum of Modern Art, NYC)

KAUFFMANN, Angelica **(KOWF-mahn)**
Swiss f (1741–1807)

KAWASE, Hasui **(kah-wah-zee)**
Japanese (1883–1957)

KELLY, Ellsworth **(KEL-lee)**
American (b. 1923)

KENSETT, John Frederick **(KEN-zet)**
American (1816–1872)

KERTÉSZ, André **(kare-tezh)**
American (b. Hungary 1894–1985)

182

Painter, portraitist | classical and mythological subjects | *Zeuxis Selecting Models for His Picture of Helen of Troy,* c. 1764 (The Annmary Brown Memorial, Brown University, Providence, Rhode Island)

Woodblock artist | landscapes | *Falling Snow at Edogawa,* 1932 (Museum of Fine Arts, Boston)

Painter, sculptor | shaped canvases | *Red, Blue, Green, 1963* (San Diego Museum of Contemporary Art, La Jolla, California)

Luminist painter | landscapes | *An Inlet on Long Island Sound,* c. 1865 (Los Angeles County Museum of Art, Los Angeles, California)

Photographer | documented NYC and Paris | *Mondrian's Eyeglasses and Pipe,* 1926 (The Art Institute of Chicago, Chicago, Illinois)

KESSEL, Jan van **(KES-sel)**
Flemish (1626–1679)

KIEFER, Anselm **(KEE-fer)**
German (b. 1945)

KIENHOLZ, Edward **(KEEN-holtz)**
American (b. 1927)

KIENHOLZ, Nancy Reddin **(KEEN-holtz)**
American *f* (b. 1927)

KIESLER, Frederich John **(KEES-ler)**
Austrian (1896–1965)

FAST FACTS

Painter | studies of nature: birds, butterflies, insects, and monkeys

Painter | woodcuts | books illustrated with woodcuts and photographs | *Departure from Egypt,* 1984 (Museum of Contemporary Art, Los Angeles, California)

Installation artist | tableaux representing the bizarre and vicious side of contemporary life | *The State Hospital,* 1966 (Museum of Modern Art, Stockholm, Sweden)

Sculptor, installation artist | funk art movement

Architect, scenic designer | *Shrine of the Book* (Jerusalem, Israel)

KING, Charles Bird **(KING)**
American (1785–1862)

KIRCHNER, Ernst Ludwig **(KEERK-ner)**
German (1880–1938)

KITAJ, Ron B. **(KI-tie)**
American (b. 1932)

KLEE, Paul **(Klay)**
Swiss (1879–1940)

Painter | *Young Omahaw, War Eagle, Little Missouri, and Pawnees,* 1821 (National Museum of American Art, Washington, DC)

Painter | *Young Woman Seated: Fränzi,* 1910–20
(Minneapolis Institute of Arts, Minneapolis, Minnesota)

Painter | figurative and narrative style | lives and works in Britain | series of self-portraits called "the bads" | *The Wedding,* 1989-93 (PC)

Painter, printmaker, teacher | childlike fantasy and imagination | produced over 2000 works in the year before his death | *Cat and Bird,* 1928 (The Museum of Modern Art, NYC)

KLEIN, Yves **(KLINE)**
French (1928–1962)

KLIMT, Gustave **(KLIMT)**
Austrian (1862–1918)

KLINE, Franz **(KLINE)**
American (1910–1962)

KNELLER, Godfrey **(NEL-ler)**
British (b. Germany 1646–1723)

KOKOSCHKA, Oskar **(ko-KOSH-kuh)**
British (b. Austria 1886–1980)

Painter | blue monochrome compositions | a leader of the European Neo-Dada movement | *Blue Sponges,* 1960 (Moderna Museet, Stockholm, Sweden)

Painter, designer | allegorical painting | Jugendstil movement | *The Kiss,* 1907–08 (Osterreichische Galerie, Vienna, Austria)

Painter | black and white compositions | a leading representative of the Abstract Expressionist movement | *Merce C.,* 1961 (National Museum of American Art, Washington, DC)

Painter, portraitist | known for his Kit-Cat Club series portaits | *Francis, Second Earl of Godolphin,* c. 1710 (National Portrait Gallery, London, England)

Painter, printmaker, poet, playwright | *The Bride of the Wind (The Tempest),* 1914 (Kunstmuseum, Basel, Switzerland)

KOLLWITZ, Käthe **(KAWL-vits)**
German f (1867–1945)

KOONING, Willem de **(KOO-ning)**
American (b. Netherlands 1904)

KOONS, Jeff **(KOONZ)**
American (b.1955)

KOSTABI, Mark **(koe-STAH-bee)**
American (b. 1960)

KOSUTH, Joseph **(KOE-sooth)**
American (b. 1945)

Graphic artist | etchings, lithographs, woodcuts | themes of death and war | *Death and Mother,* 1934 (Fogg Art Museum, Harvard University, Cambridge, Massachusetts)

Painter | Abstract Expressionist | series of violent images of women | *Woman and Bicycle,* 1952–53 (Whitney Museum of American Art, NYC)

Sculptor | simulacra | comments on modern consumption and commodification | *Rabbit,* 1986 | *Naked,* 1988

Painter | art "factory" (other artists are hired to paint his works)

Conceptual artist | installations | *One and Three Chairs,* 1965 (The Museum of Modern Art, NYC)

KRASNER, Lee **(KRAZ-ner)**
American *f* (1908–1984)

KROYER, Peter Severin **(KREU-yer)**
Danish (b. Norway 1851–1900)

KRUGER, Barbara **(KROO-ger)**
American *f* (b. 1945)

KUHN, Walt **(KOON)**
American (1877–1949)

FAST FACTS

Abstract Expressionist painter | New York School |
married to Jackson Pollock | *Imperative,* 1976 (National
Gallery of Art, Washington, DC)

Painter | *Southern Evening on a Southern Beach,* 1893
(Skagens Museum, Skagen, Denmark)

Photographer, collagist, conceptual artist | cropped and
enlarged postmodern images | *You Are a Captive
Audience,* 1983 (PC)

Painter | circus scenes | *Clown with Black Wig,* 1930 (The
Metropolitan Museum of Art, NYC)

KUNIYOSHI, Yasuo **(koo-nee-YOE-shee)**
American (b. Japan 1893–1955)

KUPKA, Frantisek **(KOOP-kuh)**
Czech (1871–1957)

NOTES:

Painter | female figure studies | *Look, It Flies!,* 1946
(Hirshhorn Museum and Sculpture Garden, Washington, DC)

Painter | pioneer of Orphism | *Piano Keyboard —The
Lake* (Prague Museum, Prague, Czechoslovakia) | *Cathedral,* 1913
(PC)

LA FARGE, John **(lah FARZH)**
American (1835–1910)

LA FRESNAYE, Roger de **(lah fray-nay)**
French (1885–1925)

LA TOUR, Georges du Mesnil de **(lah-TOOR)**
French (1593–1652)

LACROIX, Paul **(lah-kwah)**
American (active 1858–d. 1864)

LAM, Wilfredo **(LAHM)**
Cuban (1902–1982)

LANCRET, Nicolas **(lahn-KRAY)** French (1690–1743)

FAST FACTS

Painter, muralist, stained glass designer | *Wreath of Flowers,* 1866 (National Museum of American Art, Washington, DC)

Painter | influenced by Cubism | *The Conquest of the Air,* 1913 (The Museum of Modern Art, NYC)

Painter | *The Repentant Magdalene,* c. 1640 (National Gallery of Art, Washington, DC)

Still-life painter

Surrealist painter | voodoo, folklore, jungle themes | *The Jungle,* 1943 (The Museum of Modern Art, NYC)

Rococo painter, decorator | court festivities | *La Camargo Dancing,* c. 1730 (National Gallery of Art, Washington, DC)

LANDSEER, Sir Edwin **(LAN-seer)**
British (1802–1873)

LANE, Fitz Hugh **(LANE)**
American (1804–1865)

LANGE, Dorothea **(LANG)**
American *f* (1895–1965)

LANYON, Peter **(LAN-yun)**
British (1918–1964)

FAST FACTS

Painter | animals | highly praised during the Victorian era
| *The Monarch of the Glen,* 1850 (Dewar House, London, England)

Luminist painter | scenes of the Northeast coast before the
Civil War | *Ships in Ice Off Ten Pound Island, Gloucester,*
1850–60 (Museum of Fine Arts, Boston)

One of the first documentary photographers | black and
white photographs of impoverished US farm workers and
their families during the Great Depression in the 1930s |
Migrant Mother, Nipomo Valley, 1936 (Library of Congress,
Washington, DC)

Painter | abstract landscapes | *Fly Away,* 1961 (Gimpel Fils,
London, England)

LAURENCIN, Marie **(lo-ruh(n)-sa(n))**
French _f_ (1885–1956)

LAWRENCE, Jacob **(LAW-rence)**
American (b. 1917)

LAWRENCE, Thomas **(LAW-rence)**
British (1769–1830)

LE NAIN, Louis **(leh NA(N))**
French (1593–1648)

FAST FACTS

Painter, designer, book illustrator | watercolors | portraits of contemplative women | *In the Park,* 1924 (National Gallery of Art, Washington, DC)

Painter | African-American culture | *The Library,* 1960 (National Museum of American Art, Washington, DC)

Portrait painter | *Lady Robinson* | *The Duke of Wellington,* 1818 (The Bathurst Collection, Sapperton, England)

Painter | genre paintings of peasants | *A Visit to Grandmother,* 1640s (The Hermitage, St. Petersburg, Russia) | *Peasant Family,* c. 1640 (Musée du Louvre, Paris, France)

LEBRUN, Charles **(leh-BREH(N))**
French (1619–1690)

LEGA, Silvestro **(LAY-guh)**
Italian (1826–1895)

LÉGER, Fernand **(lay-zhay)**
French (1881–1955)

LEHMBRUCK, Wilhelm **(LEM-bruk)**
German (1881–1919)

LEIBOVITZ, Annie **(LEE-buh-vitz)**
American *f* (b. 1950)

FAST FACTS

Painter, furniture designer, fine craftsman | Gobelin tapestry designs | draperies and wall hangings |
Salon de Guerre, Versailles, begun 1678 in France

Painter | member of the Macchiaioli | genre scenes |
The Pergola, 1868 (Pinacoteca di Brera, Milan, Italy)

Cubist painter, sculptor | cylindrical forms | murals |
Two Women with Flowers, 1954 (The Tate Gallery, London, England)

Painter, sculptor | influence by Rodin and Maillol |
Seated Youth, 1917 (National Gallery of Art, Washington, DC)

Photographer | started her career with *Rolling Stone*
magazine | *Whoopi Goldberg, Berkeley, California,* 1984
(James Danziger Gallery, NYC)

LEIGHTON, Frederic **(LAY-tun)**
British (1830–1896)

LELY, Peter **(LEL-lee)**
British (b. Holland 1618–1680)

LEMPICKA, Tamara de **(lem-PEE-kuh)**
French *f* (1898–1980)

LEUTZE, Emanuel Gottlieb **(LOYT-zuh)**
American (b. Germany 1816–1868)

LEVINE, Jack **(leh-VEEN)**
American (b. 1915)

LEVINE, Sherrie **(leh-VEEN)** American *f* (b. 1947)

FAST FACTS

Painter, sculptor | late Victorian pseudoclassicism | *The Bath of Psyche,* 1890 (The Tate Gallery, London, England)

Painter | *Anne Hyde, Duchess of York* (Scottish National Portrait Gallery, Edinburgh, Scotland)

Painter | portraits, nude studies | covers of *Die Dame* magazine, 1930s | *Andromeda,* 1927-28 (PC)

History painter | *Washington Crossing the Delaware,* 1851 (The Metropolitan Museum of Art, NYC)

Expressionist painter | scenes of modern life | *Gangster Funeral,* 1952-53 (Whitney Museum of American Art, NYC)

Photographer, sculptor | postmodernist | *After Walker Evans,* 1936 (Mary Boone Gallery, NYC)

LEWIS, Wyndham **(LOO-is)** British (1882–1957)

LEWITT, Sol **(leh WIT)**
American (b. 1928)

LEYDEN, Lucas van **(LIE-den)**
Netherlandish (c. 1494–1533)

LEYSTER, Judith **(LIE-ster)**
Dutch f (1609–1660)

LICHTENSTEIN, Roy **(LIHK-ten-shtine)**
American (b. 1923)

LIMBOURG, Jean **(lam-BOOR)**
Franco-Flemish (d. c. 1416)

FAST FACTS

Painter, writer | *Ezra Pound,* 1939 (The Tate Gallery, London, England)

Conceptual artist, sculptor | minimalist | *Lines to Points on a Grid,* 1976 (Whitney Museum of American Art, NYC)

Painter, engraver | no known works survived

Painter | genre scenes and portraiture | *The Offer,* c. 1635 (Mauritshuis, The Hague, The Netherlands)

Painter, sculptor, Pop artist | works based on comic strips | *Whaam!,* 1963 (The Tate Gallery, London, England)

Noted manuscript painter | worked with brothers Paul and Herman Limbourg on *Les Très Riches Heures* manuscript

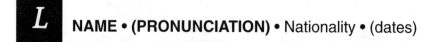

LIMBOURG, Paul **(lam-BOOR)**
Franco-Flemish (d. c. 1416)

LIPCHITZ, Jacques **(LIP-chitz)**
French (b. Lithuania 1891–1973)

LIPPI, Filippino **(LEE-pee)**
Italian (1457–1504)

LIPPI, Fra Filippo **(LEE-pee)**
Italian (1406–1469)

LISS, Johann **(LIS)**
German (1590–1629)

Noted "illuminator" | worked with brothers Herman and Jean | famous manuscript calendar, *Les Tres Riches Heures du Jean Duc de Berry (The Very Rich Hours),* 1413-16 (Musée Condé, Chantilly, France)

Sculptor | early Cubist | *Figure,* 1926–30 (Hirshorn Museum, Washington, DC)

Painter | *Tobias and the Angels,* c. 1480 (National Gallery of Art, Washington, DC)

Painter | *The Vision of Saint Augustine* (The Hermitage, Leningrad, Russia)

Painter, colorist | mythical, Biblical, genre scenes

L NAME • **(PRONUNCIATION)** • Nationality • (dates)

LISSITSKY, EL (lih-SIT-skee) (Eleazar Markowich)
Russian (1890–1941)

LOCHNER, Stefan **(LAHK-ner)**
German (c. 1410–1451)

LONG, Richard **(LONG)**
British (b.1945)

LONGHI, Pietro **(LONG-gee)**
Italian (1702–1785)

LOOS, Adolf **(LOHS)**
Austrian (1870–1933)

FAST FACTS

Painter, architect, designer | pioneer of nonobjective art
| founded Group G in Berlin | *Construction - Proun 2,*
1920 (Philadelphia Museum of Art, Philadelphia, Pennsylvania)

Painter | Gothic style | *Adoration of the Magi,* 1448
(Cologne Cathedral, Cologne, Germany)

Conceptual artist and sculptor | uses natural materials in
remote settings | works documented by photographs

Rococo painter | Venetian genre scenes | *Blind Man's
Buff,* c. 1745 (National Gallery of Art, Washington, DC)

Architect | influenced the modernist movement | houses
on Lake Geneva | *Steiner House,* Vienna, Austria,1910

LORENZETTI, Ambrogio **(lor-ren-ZET-tee)**
Italian/Sienese (active 1319–1348)

LORENZETTI, Pietro **(lor-ren-ZET-tee)**
Italian/Sienese (active 1320–1348)

LORENZO MONACO (lor-REN-zoe MAH-nuh-coe)
Italian/Florentine (c. 1370–c. 1425)

LORRAIN, Claude **(lor-RA(N))**
French (1600–1682)
See Gelee, Claude

LOTTO, Lorenzo **(LOHT-toe)**
Italian (1480–1556)

FAST FACTS

Early Renaissance painter | brother of artist Pietro
Lorenzetti | landscapes | *The Birth of the Virgin,* 1342
(Museo dell'Opera del Duomo, Siena, Italy)

Early Renaissance painter | brother of Ambrogio Lorenzetti
| *Allegory of Good Government,* 1338–39 (Sala della Pace,
Palazzo Pubblico, Siena, Italy)

Painter | follower of Antonio Gaddi | called "Lorenzo the
Monk"

Painter | established the tradition of landscape painting in
Europe | also known as Claude Gelée | *The Judgment
of Paris,* 1645–46 (National Gallery of Art, Washington, DC)

Painter, portraitist | *Andrea Odoni,* 1527 (The Royal Collection,
Hampton Court, London, England)

LOUIS, Morris **(LOO-is)**
American (1912–1962)

LUINI, Bernardino **(loo-EE-nee)** Italian (c. 1485–1532)

LUKS, George **(LEWKS)**
American (1867–1933)

LURÇAT, Jean **(lur-SAH)**
French (1892–1966)

LUTYENS, Edwin Landseer **(LUT-yens)**
English (1869–1944)

FAST FACTS

Colorfield painter | "bleeding color" | *Aphi pi,* 1961 (The Metropolitan Museum of Art, NYC)

Painter | *Young Girls Bathing* (Pinacoteca di Brera, Milan, Italy)

Painter | member of "The Eight" | city street life | *The Miner,* 1925 (National Gallery of Art, Washington, DC) | *The Polka Dot Dress,* 1927 (National Museum of American Art, Washington, DC)

Painter, tapestry designer | *Chester Dale* and *Maud Dale,* both 1928 (National Gallery of Art, Washington, DC)

Architect | classical style | *Viceroy's House,* 1920–31 (New Delhi, India)

MABUSE (mah-boo-zuh)
Netherlandish (c. 1478–1532)
(See Gossaert, Jan)

MACMONNIES, Frederick **(mak-MUN-nees)**
American (1863–1937)

MAGRITTE, René **(mah-GREET)**
Belgian (1898–1967)

MAILLOL, Aristide **(my-OH)**
French (1861–1944)

MALEVICH, Kasimir **(mal-YAY-vich)**
Russian (1878–1935)

Painter | worked in Italy the same time as Michelangelo and Raphael | *Portrait of a Merchant,* c. 1530 (National Gallery of Art, Washington, DC)

Sculptor | public monuments | student of artist Augustus Saint-Gaudens | *Bacchante and Faun,* 1894 (National Museum of American Art, Washington, DC)

Surrealist Painter | themes of reality vs. illusion | *Time Transfixed,* 1938 (The Art Institute of Chicago, Chicago, Illinois)

Sculptor | round full-figured female nudes | *The Three Nymphs,* 1930-38 (National Gallery of Art, Washington, DC)

Abstract painter | Constructivist | *Suprematism,* 1915 (Stedelijk Museum, Amsterdam, Holland)

MAN RAY, (MAN RAY) (Emmanuel Rudnitsky)
American (1890–1976)

MANET, Édouard **(mah-NAY)**
French (1832–1883)

MANGOLD, Robert **(MAN-gold)**
American (b. 1937)

MANN, Sally **(MAN)**
American f (b. 1951)

MANSART, François **(man-SAHR)**
French (1598–1666)

FAST FACTS

Surrealist photographer and painter │ *Coat Stand*, 1920 (published as a Dadaphoto in *New York Dada* magazine, 1921)

Painter │ realist style │ quite contoversial in his time │ scenes of modern life │ *Le Déjeuner sur L'Herbe*, 1863 and *Olympia,* 1863 (both at the Musée d'Orsay, Paris)

Painter │ geometrically shaped canvases │ *Attick Series III,* 1990

Photographer │ focuses on her children as subjects │ explores children' sexuality │ *Naptime*, 1989

Architect │ mansard roofs are named for him │ Château de Maisons and its gardens in Lafitte, near Paris, France

MANSART, Jules Hardouin **(man-SAHR)**
French (1646–1708)

MANSHIP, Paul **(MAN-ship)**
American (1885–1966)

MANTEGNA, Andrea **(man-TAYN-ya)**
Italian (1431–1506)

MANZÙ, Giacomo **(man-TZOO)**
Italian (b. 1908)

MAPPLETHORPE, Robert **(MAP-el-thorp)**
American (1946–1989)

FAST FACTS

Architect | designed buildings in Paris, including the Church of the Invalides, 1676–1706

Sculptor, engraver | *Prometheus Fountain,* 1932–33 (Rockefeller Center, NYC)

Painter | frescoes | *The Martyrdom of Saint Sebastian,* c. 1460 (Musée du Louvre, Paris, France)

Sculptor | religious works | *Great Cardinal,* 1955 (composed of more than 50 pieces) | *Model Undressing II,* 1965 (National Gallery of Art, Washington, DC)

Photographer | incorporated controversial sexual and racial images in his work | *Lisa Lyons* (series of fashion photographs, early 1980's) | *Self-Portrait*

MARC, Franz **(MAHRK)**
German (1880–1916)

MARDEN, Brice **(MAHR-den)**
American (b. 1938)

MARIN, John **(MA-rin)**
American (1870–1953)

MARINI, Marino **(mah-REE-nee)**
Italian (1901–1980)

222

FAST FACTS

Expressonist painter | helped found the "Blaue Reiter" movement | animal motifs | *Blue Horses,* 1911 (Walker Art Center, Minneapolis, Minnesota)

Painter, printmaker | paintings with vertical and diagonal crossing lines | monochrome works | *Card Drawing 11 (Counting),* 1982 (The Museum of Modern Art, NYC)

Early modernist painter, engraver | watercolors | landscapes and seascapes of New England | *From the Bridge, New York City,* 1933 (Wadsworth Atheneum, Hartford, Connecticut)

Painter, printmaker, sculptor | equestrian subjects | *Horseman,* 1947 (The Museum of Modern Art, NYC)

MARISOL, (MA-ri-sall) (Marisol Escobar)
French *f* (b. Paris 1930)

MARSH, Reginald **(MAHRSH)**
American (1898–1954)

MARTINI, Simone **(mahr-TEE-nee)**
Sienese (1284–1344)

MASACCIO Tommaso di Giovanni di Simone Guidi
(ma-SAH-cho) Italian/Florentine (1401–1428)

FAST FACTS

Pop artist, sculptor | active in US | mixed media | *Women and Dog*, 1964 (Whitney Museum of American Art, NYC)

Painter | scenes of New York City life | *Monday Night at the Metropolitan,* 1936 (University of Arizona Art Gallery, Tucson, Arizona)

Painter | *The Annunciation*, 1333 (Galleria degli Uffizi, Florence, Italy)

Painter | frescoes | leader of the early Italian Renaissance | *The Expulsion of Adam and Eve,* c.1425–27 (The Brancacci Chapel, Santa Maria del Carmine, Florence, Italy)

MASOLINO da Panicale **(mah-soe-LEE-noe)**
Italian/Florentine (c. 1383–c. 1447)

MASSON, André **(ma-SOH(N))**
French (1896–1987)

MATISSE, Henri **(mah-TEECE)**
French (1869–1954)

MATTA, Roberto Sebastian **(MAH-tah)**
French (b. Chile 1911)

MAX, Peter **(MAKS)**
American (b. Germany 1937)

FAST FACTS

Painter | frescoes | International Gothic style | *Adam and Eve Under the Tree of Knowledge,* 1425-28 (The Brancacci Chapel, Santa Maria del Carmine, Florence, Italy)

Painter, printmaker, illustrator | Calligraphic Surrealism | sand paintings and drawings | *Meditation on an Oak Leaf,* 1942 (The Museum of Modern Art, NYC)

Painter, illustrator, sculptor, designer | leader of the "fauves" or "wild beasts" | *The Music Lesson,* 1917 (The Barnes Foundation, Merion Station, Pennsylvania)

Painter, printmaker | *The Un-Nominator Renominated,* 1953 (Peggy Guggenheim Foundation, Venice, Italy)

Graphic artist | posters, books, murals | over 70 national magazine covers | painted Statue of Liberty portraits

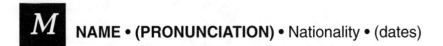

MEISSONIER, Jean Louis Ernest **(may-soe-nee-ay)**
French (1851– 1891)

MEMLING, Hans **(MEM-ling)**
Netherlandish, (b. Germany c. 1433–1494)

MENGS, Anton Raphael **(MENGKS)**
German (1728–1779)

MENZEL, Adolf von **(MEN-tzel)**
German (1815–1905)

MERYON, Charles **(me-ree-yoh(n))**
French (1821–1868)

METSU, Gabriel **(MET-soo)**
Dutch (1629–1667)

FAST FACTS

Painter, printmaker | military and battle scenes |
La Barricade, 1848 (Musée du Louvre, Paris, France)

Painter | religious themes, portraits | *Portrait of a Man with an Arrow,* c. 1470–75 (National Gallery of Art, Washington, DC)

Painter, portraitist, theoretician | a leader of the 18th c
Neoclassical revival | religious subjects

Painter, engraver | depicted the life of Frederick the Great

Engraver | etchings of Parisian scenes

Painter | portraits | historical subjects | *The Vegetable Market in Amsterdam,* c. 1660–65 (Musée du Louvre, Paris, France)

MICHELANGELO BUONARROTI
(mik-el-AN-jel-loe bwoe-nuh-ROH-tee)
Italian (1475–1564)

MIGNARD, Pierre **(meen-YAHR)**
French (1612–1695)

MILLAIS, John Everett **(mil-LAY)**
British (1829–1896)

MILLET, Jean-François **(mee-yay)**
French (1814–1875)

MINNE, Georges **(MIN-nuh)**
Belgian (1866–1941)

Architect, draftsman, painter, sculptor, poet | *David,*
1501–04 (Florence, Italy) | *The Creation of Adam*, 1508–12
(The Sistine Chapel, The Vatican, Rome, Italy)

Painter | lifelong rival of Carles Lebrun | *Portrait
d'Homme,* 1654 (Národní Galerie, Prague, Czechoslovakia)

Painter | founder of the Pre-Raphaelite Brotherhood in
1848 | *Ophelia,* 1851–52 (The Tate Gallery, London, England)

Painter | known for his scenes of peasant rural life |
The Gleaners, 1857 (Musée du Louvre, Paris, France)

Painter and sculptor | *Kneeling Boy,* 1898 (Museum of Fine Arts,
Boston)

MIRÓ, Joan **(mee-ROE)**
Spanish (1893–1983)

MIYAKE, Issey **(mee-YAH-kee)**
Japanese (b. 1939)

MODERSOHN-BECKER, Paula **(moh-der-sun bek-er)**
German *f* (1876–1907)

MODIGLIANI, Amedeo **(moe-di-lee-AH-nee)**
Italian (1884–1920)

FAST FACTS

Surrealist painter, sculptor │ Constellation series │ imaginative and playful themes │ *Dutch Interior I,* 1928 (The Museum of Modern Art, NYC) │ *Harlequinade,* 1924-25

Fashion designer and artist │ "Bustier and Skirt," 1981—cast plastic photographed by Robert Mapplethorpe │ Issey Miyake: *Photographs by Irving Penn,* 1988 (New York Graphic Society Books)

Painter and graphic artist │ self-portraits and portraits of children and mothers │ *Self-Portrait on her Sixth Wedding Day*, 1906 (Ludwig-Roselius Sammlung, Bremen, Germany)

Painter, sculptor, draftsman │ elongated figures with oval heads │ lived in Paris │ *Woman with a Fan,* 1919 (Musée d'Art Moderne de la Ville de Paris, France) │ *Chaim Soutine,* 1917 (National Gallery of Art, Washington, DC)

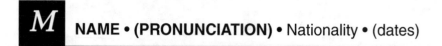

MOHOLY-NAGY, László **(MOE-hoe-lee NAHZH)**
American (b. Hungary 1895–1946)

MONDRIAN, Piet **(MON-dree-ahn)**
Dutch (1872–1944)

MONET, Claude **(moe-NAY)**
French (1840–1926)

MOORE, Henry **(MOOR)**
British (1898–1986)

FAST FACTS

Constructivist painter, sculptor, stage designer, photographer, filmmaker | kinetic sculpture | *Space Modulator,* 1940 (Collection Sybil Moholy-Nagy, NYC) | wrote *The New Vision*

Painter, sculptor | known for painting precise blocks of primary colors in grids | a founder of the De Stijl movement | *Broadway Boogie Woogie,* 1943 (The Museum of Modern Art, NYC)

Painter | a founder of the Impressionists | haystacks, waterlilies, and gardens | serial paintings on light effects | *Impression: Sunrise,* 1873 (Musée Marmottan, Paris, France) | *Déjeuner sur l'Herbe,* 1866 (Pushkin Museum, Moscow, Russia)

Sculptor | wood, plaster, bronze, stone, and terracotta | abstract and figurative work | known for reclining figures | *Knife Edge Mirror Two Piece,* 1977–78 (entrance to the East Building, National Gallery of Art, Washington, DC)

MORAN, Thomas **(mor-RAN)**
American (1837–1926)

MORANDI, Giorgio **(mor-RAN-dee)**
Italian (1890–1964)

MOREAU, Gustave **(mor-OH)**
French (1826–1898)

MORGAN, Barbara **(MOR-gan)**
American *f* (b. 1900)

MORISOT, Berthe **(MOR-ee-soe)**
French *f* (1841–1895)

FAST FACTS

Painter, printmaker | large-scale landscape views | *Cliffs of the Upper Colorado River, Wyoming Territory,* 1882 (National Museum of American Art, Washington, DC)

Painter and etcher | poetic still lifes | *Still Life with Coffeepot,* 1933 (The Museum of Modern Art, NYC)

Symbolist painter, draftsman | mythological themes | *Orpheus,* 1865 (Musée d'Orsay, Paris, France)

Photographer | dance photography | *Martha Graham*

Painter | a founder of the Impressionists | *Woman at Her Toilette,* c. 1875 (The Art Institute of Chicago, Chicago, Illinois)

MORONI, Giovanni Battista **(mor-OH-nee)**
Italian (c. 1525–1578)

MORRIS, William **(MOR-ris)**
English (1834–1896)

MORSE, Samuel F. B. **(MORCE)**
American (1791–1872)

MOTHERWELL, Robert **(MUH-ther-wel)**
American (1915–1991)

MOULINS, (Master of Moulins) **(moo-LA(N))**
French (active 1480–1500)

FAST FACTS

Painter | portraits | *Jehovah Cover–2,* 1975 (The Museum of Modern Art, NYC)

Painter, designer, craftsman | a founder of the Arts and Crafts movement | known for his wallpapers designs

History painter | landscapes | portraits | inventor of the electric telegraph | studied with Benjamin West | *James Monroe,* c. 1819 (The White House, Washington, DC)

Painter | Series of over 100 paintings reflecting on the Spanish Civil War | *Elegy to the Spanish Republic LVIII,* 1957–60 (Rose Art Museum, Brandeis University, Waltham, Massachusetts)

Painter | named for one of his works, a triptych in the Moulins Cathedral in France

MOUNT, William Sidney **(MOWNT)**
American (1807–1868)

MUCHA, Alphonse **(MOO-kuh)**
Czechoslovakian (1860–1939)

MUNCH, Edvard **(MOONK)**
Norwegian (1863–1944)

MURILLO, Bartolomé Estéban **(muh-REE-yo)**
Spanish (1617–1682)

MUYBRIDGE, Eadweard **(MOY-bridj)**
British (1830–1904)

FAST FACTS

Painter | genre scenes, portraits | *The Banjo Player in the Barn,* c. 1855 (Detroit Institute of the Arts, Detroit, Michigan)

Painter and designer | Art Nouveau posters

Painter, printmaker | expressionistic style | distorted imagery | *The Scream,* 1893 (The National Gallery, Oslo, Norway)

Painter | religious paintings of Madonnas, monks, and saints | *The Holy Family,* 1650 (Museo del Prado, Madrid, Spain)

Photographer | pioneer of motion photography | series of still photos of animals and humans | *Female Semi-Nude in Motion*, 1887, from *Human and Animal Locomotion* (George Eastman House, Rochester, New York)

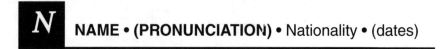

NADAR, (Gaspard-Félix Tournachon) **(nuh-DAHR)**
French (1820–1910)

NANTEUIL, Robert **(nan-TOY)**
French (1623–1678)

NASH, Paul **(NASH)**
English (1889–1946)

NAST, Thomas **(NAST)**
American (1840–1902)

NATTIER, Jean-Marc **(nah-tee-ay)**
French (1685–1766)

Pioneer photographer, writer | first to photograph Paris from a balloon | *Édouard Manet*, c. 1875 | *Sarah Bernhardt*, 1865 (Bibliothèque Nationale, Paris)

Painter, draftsman, engraver | portraits | appointed engraver to King Louis XIV in 1664

Painter, designer, illustrator, writer | *We're Making a New World*, 1918 (Imperial War Museum, London. England)

Political cartoonist | caricatures of the Republican elephant and Tammany Hall | *Hungry Office Seekers*, 1861 (The White House, Washington, DC)

Painter | delicate portraits of young ladies | *Portrait de Madame Henriette*, 1751 (Museo de Arte, Sao Paulo, Brazil)

NAUMAN, Bruce **(NOW-mahn)**
American (b. 1941)

NEVELSON, Louise **(NEH-vel-sun)**
American f (b. Russia 1900–1988)

NEWMAN, Barnett **(NEW-man)**
American (1905–1970)

NICHOLSON, Ben **(NIK-el-sun)**
English (1894–1982)

NIXON, Nicholas **(NIK-sun)**
American (b. 1947)

FAST FACTS

Sculptor, conceptual artist │ *Green Light Corridor,* 1970–71
(The Solomon R. Guggenheim Museum, NYC)

Abstract sculptor │ wall-like constructions using found
objects │ *Dawn's Wedding Chapel II, 1959 and Young
Shadows,* 1959–60 (both at the Whitney Museum of American Art, NYC)

Colorfield painter │ Abstract Expressionist │ New York
School │ *Achilles,* 1952 (National Gallery of Art, Washington, DC)

Painter │ won the first Guggenheim award in 1957 │ mar-
ried to artist Barbara Hepworth │ *August, 1956 (Val d'Orcia),*
1956 (The Tate Gallery, London, England)

Photographer │ portraiture │ cityscapes of Boston 1974–76

NOGUCHI, Isamu **(noe-GOO-chee)**
American (b. Japan 1904–1988)

NOLAN, Sidney **(NOE-lan)**
Australian (1917–1992)

NOLAND, Kenneth **(NOE-land)**
American (b. 1924)

NOLDE, Emil **(NOLE-duh)**
German (1867–1956)

NOTES:

Sculptor and abstract designer | sculpture gardens | studied with Gutzon Borglum and Brancusi | *Humpty Dumpty,* 1946 (Whitney Museum of American Art)

Painter | Australian history painting | regional landscapes with surreal overtones | series of outlaw Ned Kelly

Painter | hard-edge painting (stripes and bands of color) | *Inner Green,* 1969 (Salander-O'Reilly Galleries, Inc.)

Expressionist painter, graphic artist, etcher, engraver | briefly associated with the artists of "Die Brücke" | *The Last Supper*, 1909 (Stiftung Seebüll Ada und Emil Nolde, Neukirchen, Germany)

 NAME • (PRONUNCIATION) • Nationality • (dates)

O'KEEFFE, Georgia **(oh-KEEF)**
American *f* (1887–1986)

O'SULLIVAN, Timothy H. **(oh-SUL-li-van)**
American (1840–1882)

OLDENBURG, Claes **(OLE-den-berg)**
American (b. 1929)

OLITSKI, Jules **(oh-LIT-skee)**
American (b. Russia 1922)

OPPENHEIM, Meret **(AHP-pen-hime)**
Swiss *f* (1913–1985)

FAST FACTS

Painter | wife of photographer Alfred Stieglitz | oversized flowers | *Yellow Cactus Flowers,* 1929 (Fort Worth Art Center, Fort Worth, Texas)

Photographer | one of earliest photographers to travel West in 1860s and 1870s | apprentice of Matthew Brady

Pop artist, sculptor | *Giant Hamburger,* 1962 (Art Gallery of Ontario, Toronto, Canada) | *Stake Hitch,* 1984 (with artist and wife Coosje van Bruggen) (Dallas Museum of Art, Dallas, Texas)

Abstract painter and sculptor | Colorfield painting

Sculptor | *Object,* 1936 (fur-covered cup, saucer, and spoon) (The Museum of Modern Art, NYC)

ORCAGNA, Andrea di Cione **(or-KAHN-yuh)**
Italian (c. 1308–1368)

ORGAN, Bryan **(OR-guhn)**
English (b. 1935)

OROZCO, José Clemente **(or-OHZ-koe)**
Mexican (1883–1949)

ORPEN, William **(OR-pen)**
British (1878–1931)

OSTADE, Adriaen van **(OH-stah-duh)**
Dutch (1610–1685)

FAST FACTS

Painter, sculptor │ "orcagna" is Florentine slang for archangel │ *Saint Matthew Surrounded by Scenes of His Life,* 1367 (Galleria degli Uffizi, Florence, Italy)

Painter, portraitist │ *Elton John* │ *Charles, Prince of Wales,* 1980 (National Portrait Gallery, London, England)

Painter, muralist │ *Zapatistas,* 1931 (Museum of Modern Art, NYC) │ *The Trench,* (First floor, Westpatio, Escuela National Preparatoria, México)

Painter │ known for his "conversation pieces" depicting everyday scenes │ *The Cafe Royal in London,* 1912 (Musée d'Orsay, Paris, France)

Painter, engraver │ genre scenes of taverns and village fairs │ *Interior with Peasants,* 1663 (The Wallace Collection, London, England)

OUD, Jacobus Johannes Pieter **(OWT)**
Dutch (1890–1963)

OVERBECK, Johann Friedrich **(OH-ver-bek)**
German (1789–1869)

NOTES:

Architect and city planner | member of the de Stijl movement | *Shell Building,* 1938 (The Hague, The Netherlands)

Painter | member of the Nazarenes | executed medieval religious paintings | worked in the High Renaissance style

PAGE, William **(PAYJ)**
American (1811–1885)

PAIK, Nam June **(PIK)**
American (b. Korea 1932)

PALMA, Jacopo, il Vecchio **(PAHL-muh)**
Italian/Venetian (1480–1528)

PALMER, Samuel **(PAHL-mer)**
British (1805–1881)

PANNINI, Giovanni Paolo **(pah-NEE-nee)**
Italian (c. 1691–1765)

Painter | portraits, biblical, and mythological scenes |
Flight into Egypt

Video installation artist | distorted imagery | *Niche in T,*
1994 (Hara Museum of Contemporary Art, Tokyo, Japan)

Painter | landscapes and portraits of women | *The Three
Graces,* before 1525 (Gemäldegalerie, Dresden, Germany)

Visionary landscape painter | mixed media, including
watercolor, gouache, and India ink | *In a Shoreham
Garden,* 1830–35 (The Victoria and Albert Museum, London, England)

Painter | historical subjects | city views of Rome depict-
ing celebrations and festivals | *The Interior of St. Peter's in
Rome,* 1731 (National Gallery of Art, Washington, DC)

PAOLOZZI, Eduardo **(pow-LOHT-zee)**
Scottish (b. 1924)

PARMIGIANINO, IL (pahr-mi-jah-NEE-noe)
(Girolamo Francesco Maria Mazzola)
Italian (1503–1540)

PARRISH, Maxfield **(PAR-ish)**
American (1870–1966)

PATINIR, Joachim **(pa-tin-EER)**
Netherlandish (c. 1485–c. 1524)

PEALE, Charles Willson **(PEEL)**
American (1741–1827)

Printmaker, sculptor | early English Pop artist |
Japanese War God, 1958 (Albright-Knox Gallery, Buffalo, New York)

Mannerist painter | *Madonna with the Long Neck,* c. 1535
(Galleria degli Uffizi, Florence, Italy)

Painter, illustrator of books and magazines | *Mother Goose
in Prose,* 1897 | *Contentment,* 1927 (Alma Gilbert Gallery,
Burlingame, California)

Painter | narrative landscape paintings | *Saint Jerome in
a Rocky Landscape,* c. 1500 (The National Gallery, London, England)

Painter, scientist | portraits | studied with Benjamin West
| *Mrs. James Smith and Grandson,* 1776 (National Musem of
American Art, Washington, DC)

PEALE, Raphaelle **(PEEL)**
American (1774–1825)

PEALE, Rembrandt **(PEEL)**
American (1778–1860)

PECHSTEIN, Max **(PEK-shtine)**
German (1881-1955)

PEI, I. M. (Ieoh Ming) **(PAY)**
American (b China 1917)

PENN, Irving **(PEN)**
American (b. 1917)

FAST FACTS

Painter | trompe l'oeil (trick the eye) still lifes | son of artist Charles Willson Peale | *Still Life–Strawberries, Nuts, Etc.,* 1822 (The Art Institute of Chicago, Chicago, Illinois)

Painter | portraits of presidents | son of artist Charles Willson Peale | *Thomas Jefferson,* 1800 and *George Washington,* c. 1823 (both at The White House, Washington, DC)

Expressionist painter, printmaker | *The Harbour,* 1922 (Stedelijik Museum, Amsterdam, Holland)

Architect | John Hancock Tower (Boston, Massachusetts) | Glass Pyramids (Musée du Louvre, Paris, France)

Photographer | fashion, portraits, advertisements | worked for *Vogue* magazine

PENNELL, Joseph **(PEN-ull)**
American (1860–1926)

PEREIRA, Irene Rice **(puh-RARE-uh)**
American *f* (1907–1971)

PERRET, Auguste **(peu-RAY)**
French (1874–1954)

PERUGINO, Pietro **(pe-roo-JEE-noe)**
Italian (1446–1524)

PETO, John Frederick **(PEE-toe)**
American (1854–1907)

FAST FACTS

Printmaker, etcher, book illustrator | covered WWI for *The Illustrated London News* and *The London Daily Chronicle*

Geometric, abstract painter | transparent surfaces | *Transfluent Lines,* 1946 (National Gallery of Art, Washington, DC)

Architect | exposed concrete beams | Church of Notre Dame at Le Raincy, 1922–23 (outside Paris, France)

Painter | pupil of artist Andrea del Verrocchio | decorated the "Sala del Cambio" | taught Raphael | *The Virgin and Child with Saints,* c.1497 (Pinacoteca Nazionale, Bologna, Italy)

Painter | trompe l'oeil still lifes | *Lights of Other Days,* 1906 (The Art Institute of Chicago, Chicago, Illinois)

PFAFF, Judy **(FAF)**
American *f* (b. England 1946)

PHIDIAS (FI-dee-us)
Greek (c. 500–432 BC)

PIAZZETTA, Giovanni Battista **(pee-aht-ZEH-tuh)**
Venetian/Italian (1682–1754)

PICABIA, Francis **(pee-KAH-bee-ah)**
French (1879–1953)

PICASSO, Pablo Ruiz y **(pee-KAH-soe)**
Spanish (1881–1973)

FAST FACTS

Abstract artist ｜ *Dragons,* 1981 (Installation at the Whitney Museum Biennial, NYC)

Sculptor ｜ sculptures in the Parthenon, c. 438–32 B.C. (Athens, Greece) ｜ Athena Parthenos (reconstructed) (Royal Ontario Museum, Toronto, Canada)

Rococo painter, printmaker ｜ *L'Indovina (The Fortune Teller),* 1740 (Gallerie dell'Accademia, Venice, Italy)

Cubist and Surrealist painter ｜ *M'Amenez-y,* 1919–20 (The Museum of Modern Art, NYC)

Painter, sculptor ｜ a founder of the Cubist movement ｜ *Guernica,* 1937 (Museo del Prado, Madrid, Spain) ｜ *Les Demoiselles d'Avignon,* 1906–07 (The Museum of Modern Art, NYC)

PIERO DELLA FRANCESCA
(pee-AIR-oh del-luh fran-CHESS-kah) Italian (1416–1492)

PIERO DI COSIMO (pee-AIR-oh di KAH-see-mo)
Italian (1462–1521)

PIETRO DA CORTONA
(pee-AY-troe dah kor-TOE-nuh) Italian (1596–1669)

PINDELL, Howardena *f* **(pin-DEL)**
American (b. 1943)

PIPER, Adrian **(PY-per)** American (b. 1948)

PIPPIN, Horace **(PIP-pin)**
American (1888–1946)

FAST FACTS

Painter of the early Renaissance | statuesque style |
The Baptism, c.1442 (The National Gallery, London, England)

Painter | strange mythological scenes | *The Forest Fire,*
1480 (The Ashmolean Museum, Oxford, England)

Architect and painter | *Glorification of the Rule of Urban
VIII,* 1633-39 (ceiling fresco in the Palazzo Barberini, Rome, Italy)

Painter, collagist | organized *Autobiography: In Her Own Image,*
an exhibition of the work of 20 East Coast women of color, 1988

Installation artist | video art | explores racial tensions

Painter | bold, primitivist style depicting African-American
life | *John Brown Going to His Hanging,* 1942 (Pennsylvania
Academy of the Fine Arts, Philadelphia, Pennsylvania)

PIRANESI, Giovanni Battista **(peer-ah-NAY-zee)**
Italian (1720–1778)

PISANELLO, IL (Antonio Pisano) **(pee-zah-NEL-loe)**
Italian (c. 1395–c. 1455)

PISANO, Andrea **(pee-ZAH-no)**
Italian/Florentine (1270–1349)

PISANO, Nicola **(pee-ZAH-no)**
Italian (active 1258–1278)

PISSARRO, Camille **(pee-ZAHR-roe)**
French (b. West Indies 1830–1903)

POIRET, Paul **(pwah-RAY)** French (1879–1944)

FAST FACTS

Printmaker, architect, draftsman | series of prison engravings, begun c. 1745 and reworked in 1761

Panel painter, portraitist | International Gothic style | *Ginevra d' Este,* c. 1440 (Musée du Louvre, Paris, France)

Sculptor, architect | made the earliest set of gilded bronze doors for the Baptistry in Florence, Italy, 1330-37

Sculptor | works influenced by late Roman sculpture | Pulpit of the Baptistry of Pisa Cathedral, 1259–60 (Pisa, Italy)

Impressionist painter | cityscapes | *Boulevard des Italiens, Morning, Sunlight,* 1897 (National Gallery of Art, Washington, DC)

Couturier and leader of fashion design in the early 1900s

POLIAKOFF, Serge **(puh-lee-ah-KOFF)**
Russian (1906–1969)

POLKE, Sigmar **(POLE-kuh**)
German (b. 1941)

POLLAIUOLO, Antonio del **(pol-eye-WOE-loe)**
Italian (c.1433–1498)

POLLOCK, Jackson **(PAHL-uk)**
American (1912–1956)

POLYKLEITOS OF ARGOS (pah-lee-KLY-tis)
Greek (active c. 450 BC–c. 420 BC)

Abstract painter | immigrated to Paris | *Composition,*
1950 (The Solomon R. Guggenheim Museum, NYC)

Painter | *Three Girls,* 1979 (Anthony d'Offay Gallery, London,
England)

Sculptor, painter, goldsmith, engraver | studied the details
of human anatomy | *Hercules and Antalus,* c. 1475 (Museo
Nazionale del Bargello, Florence, Italy)

Abstract Expressionist painter | known for his drip paint-
ings | married to artist Lee Krasner | *Blue Poles,* 1952
(The National Gallery of Art, Canberra, Australia)

Sculptor, aesthetician | rival of Phidias | athletes | leg-
endary colossal statue, *Hera in Argos* | *Doryphorus (Spear
Bearer),* c. 450–40 (National Museum, Naples, Italy)

PONTORMO, Jacopo da **(pahn-TORE-moe)**
Italian/Florentine (1494–1556)

POONS, Larry **(POONZ)**
American (b. Tokyo 1937)

POPOVA, Liubov Sergeevna **(pah-PO-vuh)**
Russian *f* (1889–1924)

POST, William **(POAST)**
American (1857–1925)

POTTER, Beatrix **(PAH-ter)**
British *f* (1866–1943)

FAST FACTS

Mannerist painter | *The Deposition,* c. 1525 (Santa Felicità, Florence, Italy)

Painter | *Night Journey,* 1968 (Carter Burden Collection, NYC)

Constructivist painter and textile designer | *Composition,* 1921 (The Museum of Modern Art, NYC)

Photographer | member of the Photo-Secessionist movement | subjects included ladies at leisure

Author and illustrator | *Peter Rabbit* books

POUSSIN, Nicholas **(poo-SA(N))**
French (1594–1665)

POWERS, Hiram **(POW-ers)**
American (1805–1873)

PRAXITELES (prak-SIT-el-eez)
Greek (c. 370–330 BC)

PRENDERGAST, Maurice **(PREN-der-gast)**
American (1859–1924)

FAST FACTS

Neo-classical painter | landscape and history painting |
Court painter to Louis XIII 1640-43 | *Echo and Narcissus*
| *The Burial of Phocion,* 1648 (both at Musée du Louvre, Paris, France)

Sculptor | Neoclassical style | designs modeled in plaster
and finished in marble by master carvers | *Andrew Jackson,* 1835 (National Museum of American Art, Washington, DC)

Sculptor | worked in marble and bronze | statue, *Hermes Carrying the Infant Dionysus,* c. 350–330 BC (Archaeological Museum, Olympia, Greece)

Painter | oil and watercolor | outdoor scenes of everyday
life | member of "The Eight" | *Revere Beach,*
c. 1896–97 (The White House, Washington, DC)

PRIMATICCIO, Francesco **(pree-muh-TEE-choe)**
Italian, active in France (c. 1504–1570)

PRUD'HON, Pierre-Paul **(proo-DOH(N))**
French (1758–1823)

PURYEAR, Martin **(PER-yeer)**
American (b. 1941)

PUVIS DE CHAVANNES, Pierre
(poo-vee duh shah-VAHN) French (1824–1898)

NOTES:

Painter, sculptor | founded the School of Fontainbleau |
Danaë, c. 1533–40 (Chateau de Fontainebleau, Fontainebleau, France)

Painter, sculptor, illustrator, draftsman | *The Empress Josephine,* 1805 (Musée du Louvre, Paris, France)

Sculptor | wrapping and interweaving of layers | *The Spell,* 1985 (Collection of the artist)

Symbolist painter, muralist | *L'Hiver,* 1891–92 (fresco at the Hôtel de Ville, Paris, France)

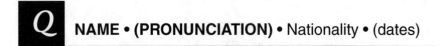

QUERCIA, Jacopo della **(KWEAR-chuh)**
Italian/Sienese (c. 1374–1438)

QUIDOR, John **(KEE-dore)**
American (1801–1881)

NOTES:

Sculptor | sculptures and fountains in Siena, Italy | influenced Michelangelo | *Virgin and Child with Saints,* c. 1423–25 (San Martino, Siena, Italy)

Painter, illustrator | exaggerated figures and expressions | *The Return of Rip Van Winkle,* c. 1829 (National Gallery of Art, Washington, DC)

RABUZIN, Ivan **(RA-byoo-zin)**
Croatian (b. 1919)

RAEBURN, Henry **(RAY-bern)**
Scottish (1756–1823)

RAIMONDI, Marcantonio **(ray-MOHN-dee)**
Bolognese (c. 1480–1534)

RAMSAY, Allan **(RAM-zay)**
Scottish (1713–1784)

RAPHAEL (RAH-fy-el) (Raffaello Sanzio)
Italian (1483–1520)

FAST FACTS

Painter | Innocent art | School of "Hlebine"

Painter, portraitist | *The Reverend Robert Walker Skating on Duddingston Loch,* 1784 (National Gallery of Scotland, Edinburgh, Scotland)

Engraver | reproduced works by Raphael and Michelangelo | *The Judgment of Paris* (after Raphael), c. 1520

Painter | *Portrait of the Artist's Wife,* 1754–55 (National Gallery of Scotland, Edinburgh, Scotland)

Painter, architect | High Renaissance style | religious and mythological scenes | portraits |
The Belle Jardinière, 1507 (Musée du Louvre, Paris, France)

RAUSCHENBERG, Robert **(ROW-shen-berg)**
American (b. 1925)

RAZZA, A.C. **(RAZ-zuh)**
American (b. 1954)

REDON, Odilon **(re-DOH(N))**
French (1840–1916)

REGO, Paula **(REE-goe)**
Portuguese f (b. 1935)

REINHARDT, Ad (Adolphe Frederick) **(RINE-hahrt)**
American (1913–1967)

REJLANDER, Oscar Gustave **(RAY-lan-der)**
Swedish (1813–1875)

Pop Artist, painter, sculptor │ incorporates newspaper clippings in his pop culture images │ *Preview,* 1974 (from the Hoarfrost series) (The Museum of Modern Art, NYC)

Painter, collagist │ "paint-skin collages" │ *The Findings,* 1991 (Collection of the artist)

Painter │ drawings, engravings, decorative arts │ *The Cyclops,* 1898–1900 (The Museum of Modern Art, NYC)

Painter, sculptor │ theatrical compositions with erotic undertones │ *The Family,* 1988 (Saatchi Collection, London, England) │ *The Policeman's Daughter,* 1987

Sculptor │ *Sleeping Children*, 1969 (National Museum of American Art, Washington, DC)

Photographer │ active in England │ *Hard Times,* 1860 (George Eastman House, Rochester, New York)

REMBRANDT Harmensz van Rijn **(REM-brant)**
Dutch (1606–1669)

REMINGTON, Frederic **(REM-ing-tun)**
American (1861–1909)

RENI, Guido **(RAY-nee)**
Italian (1575–1642)

RENOIR, Pierre-Auguste **(ren-WAHR)**
French (1841–1919)

REPIN, Ilya **(RAY-pin)**
Russian (1844–1930)

FAST FACTS

Painter, draftsman, printmaker | dramatic psychological portraits | approximately 100 self-portraits | *Portrait of the Artist,* c. 1665 (The Iveagh Bequest, Kenwood, London, England)

Painter, sculptor, illustrator | themes of the Old West cast in bronze | *Stampeded by Lightning,* 1908 (Gilcrease Institute of American History and Art, Tulsa, Oklahoma)

Baroque painter | *Aurora,* 1613–14 (ceiling fresco in the Casino Rospigliosi, Rome, Italy)

Impressionist painter | portraits, figure paintings | *Le Moulin de la Galette,* 1876 (Musée d'Orsay, Paris, France)

Painter, portraitist, landscape artist | represented everyday Russian life | *The Volga Boatmen,* 1870–73 (State Russian Museum, St. Petersburg, Russia)

REYNOLDS, Joshua **(REH-nuldz)**
English (1723–1792)

RIBERA, Jusepe de **(ree-VARE-uh)**
Spanish (1590–1652)

RICCI, Marco **(REE-chee)**
Italian/Venetian (1676–1730)

RICCI, Sebastiano **(REE-chee)**
Italian/Venetian (1659–1734)

RICHTER, Gerhard **(RIKH-ter)**
German (b. 1932)

FAST FACTS

Painter, portraitist, aesthetic theorist | *Miss Bowles and her Dog,* 1775 (The Wallace Collection, London, England)

Painter and etcher | *Apollo and Marsyas*, 1637 (Museo di San Martino, Naples, Italy)

Painter | small landscapes | *Landscape with Ancient Ruins* (Museo Civico d'Arte e Storia, Venice, Italy)

Painter, etcher | decorative themes | *Nocturnal Vision (Dream of Aesculapius)* (Galleria dell'Accademia, Venice, Italy)

Painter | *Betty,* 1988 (portrait of the artist's daughter) (Collection of the artist at the Saint Louis Museum of Art, Saint Louis, Missouri))

RIEMENSCHNEIDER, Tilman **(REE-men-shny-der)**
German (1460–1531)

RIGAUD, Hyacinthe **(ree-GOE)**
French (1659–1743)

RIIS, Jacob **(REECE)**
American (b. Denmark 1849–1914)

RILEY, Bridget **(RY-lee)**
British f (b. 1931)

RIMMER, William **(RIM-mer)**
American (1816–1879)

FAST FACTS

Sculptor, civic official │ late Gothic style │ known for his limewood sculptures │ *Saint Matthew,* 1495–1505 (Staatliche Museen, Berlin-Dahlem, Germany)

Painter, portraitist │ known for his regal state portraits │ *Louis XIV,* 1701 (Musée du Louvre, Paris, France)

Photographer, writer, police reporter │ revealed social and economic injustices in his work │ *Bandits' Roost,* c.1888 (Museum of the City of New York, NYC)

Op artist │ abstract, formalist paintings │ *Drift No. 2,* 1966 (Albright-Knox Art Gallery, Buffalo, New York) │ *Ra,* 1980

Sculptor, writer on art theory │ *Dying Centaur* (cast bronze), c. 1869 (National Gallery of Art, Washington, DC)

RINGGOLD, Faith **(RIN-gold)**
American f (b. 1934)

RIOPELLE, Jean-Paul **(ree-oh-PEL)**
Canadian (b. 1923)

RIVERA, Diego **(ree-VARE-uh)**
Mexican (1886–1957)

RIVERS, Larry **(RIV-ers)**
American (b. 1923)

ROBERT, Hubert **(roe-BARE)**
French (1733–1808)

Painter, quiltmaker │ narrative writing and painting on quilts
The Wedding: Lover's Quilt No. 1, 1986 (PC)

Abstract painter │ lives in Paris │ *Large Composition,*
1949–51 (PC)

Painter, muralist │ married to artist Frida Kahlo │ *Mexico
Today, Mexico Tomorrow,* 1936 (The National Palace, Mexico City,
Mexico)

Painter, sculptor │ studied under Hans Hoffmann │ *Parts
of the Face,* 1961 (The Tate Gallery, London, England) │ *Double
Portrait of Berdie,* 1955 (Whitney Museum of American Art, NYC)

Painter │ antique ruins in landscapes │ *The Fountains,*
1787–88 (The Art Institute of Chicago, Chicago, Illinois)

R NAME • **(PRONUNCIATION)** • Nationality • (dates)

ROBINSON, Henry Peach **(RAH-bin-sun)**
English (1830–1901)

ROCHE, Kevin **(ROACH)**
American (b. Ireland 1922)

ROCKWELL, Norman **(RAHK-wel)**
American (1894–1978)

RODCHENKO, Aleksandr **(rohd-CHEN-koe)**
Russian (1891–1956)

RODIN, Auguste **(roe-DA(N))**
French (1840–1917)

FAST FACTS

Photographer and painter | carefully composed "art photographs" | mid-Victorian style | wrote *Pictorial Effect in Photography,* 1869 | *Women and Children in the Country,* 1860 (George Eastman House, Rochester, New York)

Architect | studied with Mies van der Rohe | Eero Saarinen's design associate | *CBS Building* (NYC)

Painter, illustrator | *Saturday Evening Post* magazine covers (first appeared May 1916)

Painter, photographer, sculptor, industrial designer | *Hanging Construction,* c. 1920 (The Museum of Modern Art, NYC)

Sculptor | bronze, marble | *The Thinker,* 1879–89 (The Metropolitan Museum of Art, NYC) | *The Kiss,* 1886–98 (Musée National Auguste Rodin, Paris, France)

ROESEN, Severin **(REU-zen)**
American (b. Germany c. 1815–1872)

ROHE, Ludwig Mies van der **(RO-eh)**
German (1886–1969)

ROMNEY, George **(ROM-nee)**
English (1734–1802)

ROSA, Salvator **(ROE-zuh)**
Italian (1615–1673)

ROSENQUIST, James **(ROE-zen-kwist)**
American (b. 1933)

Still-life painter │ *Floral Still Life with Nest of Eggs,*
c. 1851–52 (The White House, Washington, DC)

Architect, furniture designer │ director of the Bauhaus
1930–33 │ glass skyscrapers, cantilever chair │ *The
Seagram Building* (NYC)

Historical painter │ known for his series of portaits of
Emma Hart (Lady Hamilton) Miranda, c. 1786

Painter, printmaker, landscape artist │ battle scenes │
marine subjects │ *Landscape With a Bridge,* c. 1640
(Palazzo Pitti, Florence, Italy)

Painter, billboard artist │ *Welcome to the Water Planet,*
1987 (National Gallery of Art, Washington, DC)

ROSS, Judith Joy **(ROSS)**
American ∫ (b. 1946)

ROSSELLI, Cosimo **(roe-ZEL-lee)**
Italian/Florentine (1439–1507)

ROSSETTI, Dante Gabriel **(roe-ZET-tee)**
English (1828–1882)

ROSSO FIORENTINO, **Il** (Giovanni Battista di Jacopo)
(ROHS-so fee-or-en-TEE-noe)
Italian (1494–1540)

ROTHKO, Mark **(RAHTH-koe)**
American (b Russia 1902–1970)

FAST FACTS

Portrait photographer | *Contemporaries: A Photographic Series—Judith Joy Ross,* 1995 (The Museum of Modern Art, NYC)

Painter | paintings in the Sistine Chapel | *The Virgin and Child Enthroned with Saints,* c. 1478 (The Fitzwilliam Museum, Cambridge, England)

Painter, poet | a founder of the Pre-Raphaelite Brotherhood | *The Day-dream,* 1880 (Victoria and Albert Museum, London, England)

Painter, engraver | *The Dead Christ with Angels,* c. 1524–27 (Museum of Fine Arts, Boston)

Abstract Expressionist artist | Colorfield painter | large stained canvases | *Sacrifice,* 1946 (The Solomon R. Guggenheim Museum, NYC)

 R NAME • **(PRONUNCIATION)** • Nationality • (dates)

ROUAULT, Georges **(roo-OH)**
French (1871–1958)

ROUBILIAC, Louis-François **(roo-bee-YAK)**
French (1695–1762)

ROUSSEAU, Henri **(roo-SOE)**
French (1844–1910)

ROUSSEAU, Théodore **(roo-SOE)**
French (1812–1867)

ROWLANDSON, Thomas **(ROW-land-sun)**
English (1756–1827)

FAST FACTS

Expressionist painter | etcher, illustrator, designer | religious themes | student of Gustave Moreau | *The Old King,* 1936 (Carnegie Museum of Art, Pittsburgh, Pennsylvania)

Rococo sculptor | settled in England | *Sir Isaac Newton,* 1755 (Trinity College, Cambridge, England)

Primative painter | imaginative and naive manner | exotic junglescapes | *The Sleeping Gypsy,* 1897 (The Museum of Modern Art, NYC) | *The Monkeys,* c. 1906

Landscape painter | Barbizon School | influenced by artists John Constable and Richard Parkes Bonington

Painter, illustrator, watercolorist, caricaturist | *The Dance of Death,* 1815–16

RUBENS, Peter Paul **(ROO-benz)**
Flemish (1577–1640)

RUISDAEL, Jacob van **(RIZE-dahl)**
Dutch (1628/29–1682)

RUSCHA, Edward **(ROO-shuh)**
American (b. 1937)

RUSSELL, Charles Marion **(RUS-sel)**
American (1864–1926)

RUYSCH, Rachel **(ROYCE)**
Dutch *f* (1664–1750)

FAST FACTS

Painter and printmaker | religious and allegorical paintings
| portraits and landscapes | *Abduction of the Daughters
of Leucippus,* 1618–20 (Alte Pinakothek, Munich, Germany)

Painter | realist landscapes | *The Jewish Cemetery,*
c. 1655 (Detroit Institute of the Arts, Detroit, Michigan)

Pop artist, painter, photographer | photo series of gasoline
filling stations | *Noise, Pencil, Broken Pencil, Cheap
Western,* 1963 (Virginia Museum of Fine Arts, Richmond, Virginia)

Painter, sculptor | Western scenes and sculptures of cowboy
and Native American life | *Attack on the Wagon Train,* 1904 (PC)

Painter | floral still-lifes | *Roses, Convolvulus, Poppies and
Other Flowers in an Urn on a Stone Ledge,* c. 1745 (National
Museum for Women in the Arts, Washington, DC

RYDER, Albert Pinkham **(RY-der)**
American (1847–1917)

RYMAN, Robert **(RY-man)**
American (b. 1930)

NOTES:

FAST FACTS

Painter | eerie and haunting themes | *The Flying Dutchman,* c. 1887 (National Museum of American Art, Washington, DC) | *The Race Track,* or *Death on a Pale Horse,* c. 1910 (Cleveland Museum of Art, Cleveland, Ohio)

Painter | *Twin,* 1966 (The Museum of Modern Art, NYC)

SAINT-GAUDENS, Augustus **(SAYNT-GAW-denz)**
American (b. Ireland 1848–1907)

SALVIATI, Francesco **(sal-vee-AH-tee)**
Italian/Florentine (1510–1563)

SÁNCHEZ-COTÁN, Juan **(SAHN-chez koe-TAHN)**
Spanish (1561–1627)

SANDBY, Paul **(SAND-bee)**
English (1725–1809)

SANDER, Auguste **(SAN-der)**
German (1876–1964)

FAST FACTS

Sculptor | realist relief sculpture | war memorials | *Shaw Memorial,* 1897 (Boston Commons, Boston, Massachusetts) | *Diana of the Tower,* 1899 (National Gallery of Art, Washington, DC)

Painter, decorative artist | *Bathsheba Calling at David's House,* c. 1552-54 (fresco in the Sacchetti Palace, Rome, Italy)

Painter | still lifes | *Melon, Pumpkin, Cabbage and Quince* (Timken Art Gallery, San Diego, California)

Painter, watercolorist, printmaker | landscapes | pioneer of aquatint medium

Photographer | German life in the early 20th century | photographic documentary: *Men in the 20th Century*

SANSOVINO, Jacopo **(san-soe-VEE-noe)**
Italian (1537–1570)

SARGENT, John Singer **(SAHR-jent)**
American (1856–1925)

SASSETTA, Stefano di Giovanni **(sah-SET-tuh)**
Italian/Sienese (c. 1392–1450)

SAVERY, Roelandt **(sah-vay-ree)**
Flemish (1576–1639)

SCHAD, Christian **(SHAHD)**
German (1894–1982)

FAST FACTS

Sculptor and architect of the Florentine Renaissance | religious works | *La Zecca (The Mint),* 1535–45, and *State Library,* begun 1537 (San Marco, Venice, Italy)

Portrait painter | watercolor landscapes | *Madame X* or *Madame Gautreau,* 1884 (The Metropolitan Museum of Art, NYC)

Painter | Gothic style | *Altarpiece of the Madonna of the Snows,* 1430–33 (Palazzo Pitti, Florence, Italy)

Painter, printmaker | animal and forest scenes | *Orpheus Charming the Animals,* c. 1625 (Museo di Castelvecchio, Verona, Italy)

Painter | pyschological themes | *Portrait of Doctor Haustein,* 1928 (Fundación Colección Thyssen-Bornemisza, Madrid, Spain)

SCHAPIRO, Miriam **(shah-PEE-roe)**
American f (b. 1923)

SCHIAVONE, Andrea Meldolla **(skee-ah-VOE-nay)**
Italian/Venetian (c. 1510–1563)

SCHIELE, Egon **(SHEE-luh)**
Austrian (1890–1918)

SCHLEMMER, Oskar **(SHLEM-mer)**
German (1888–1943)

SCHMIDT-ROTLUFF, Karl **(shmit RAHT-luf)**
German (1884–1976)

FAST FACTS

Painter, teacher, collagist, sculptor | *Anna and David,* 1987
| *Rondo,* artist's book published in 1989 (Bedford Arts)

Painter, engraver | mythological and religious themes |
pioneer of Venetian Mannerism

Expressionist painter and graphic designer | male and
female nudes | *The Embrace,* 1917 (Österreichisches Galerie,
Vienna, Austria)

Painter, sculptor, teacher | Constructivist | *Bauhaus
Stairway,* 1932 (The Museum of Modern Art, NYC)

Painter, wood engraver | founding member of Die Brücke
| *Lofthus,* 1911 (Kunsthalle, Hamburg, Germany)

SCHNABEL, Julian **(SHNAH-bel)**
American (b. 1951)

SCHONGAUER, Martin **(SHONE-gow-er)**
German (c. 1430–1491)

SCHWITTERS, Kurt **(SHVIT-erz)**
Geman (1887–1948)

SCOREL, Jan van **(SKOR-el)**
Netherlandish (1495–1562)

**SEBASTIANO DEL PIOMBO
(se-bas-tee-AH-noe del PYOM-boe)**
Italian (c. 1485–1547)

FAST FACTS

Neo-expressionist painter │ *Humanity Asleep,* 1982 (The Tate Gallery, London, England)

Painter, engraver │ Gothic style │ *The Madonna of the Rose-Bower,* 1473 (Church of Saint Martin, Colmar, France)

Abstract painter, collagist, poet, environmental sculptor │ *Merz 378,* 1922 (Folkwag Museum, Essen, Germany)

Painter │ *Mary Magdalen,* c. 1540 (Rijkmuseum, Amsterdam Holland)

Painter │ *Christ Carrying the Cross,* c. 1520 (Museo del Prado, Madrid, Spain) │ *Judith,* 1510 (The National Gallery, London, England)

SEGAL, George **(SEE-gul)**
American (b. 1924)

SERRA, Richard **(SER-ruh)**
American (b. 1939)

SERRANO, Andres **(se-RAH-noh)**
American (b. 1953)

SÉRUSIER, Paul **(se-ROO-see-ay)**
French (1863–1927)

SEURAT, Georges **(ser-AH)**
French (1859–1891)

Sculptor | life-sized white plaster figures | *John Chamberlain Working,* 1965-67 (The Museum of Modern Art, NYC)

Sculptor | designs art for public spaces | *Clara, Clara,* 1983 (Originally at the Place de la Concorde, now at Square de Choissy, Paris, France)

Photographer | controversial religious images | *Piss Christ,* 1987 (PC)

Painter | a founder of the Nabis | *Landscape of the Bois d'Amour (The Talisman),* 1888 (Collection de la famille Denis)

Post Impressionist painter | developed the pointillist technique with Paul Signac | *Sunday Afternoon on the Island of La Grande Jatte,* 1884–86 (The Art Institute of Chicago, Chicago, Illinois)

SEVERINI, Gino **(seh-ver-EE-nee)**
Italian (1883–1966)

SHAHN, Ben **(SHAHN)**
American (1898–1969)

SHEELER, Charles **(SHEE-ler)**
American (1883–1965)

SHERMAN, Cindy **(SHER-man)**
American *f* (b. 1954)

SIBERECHTS, Jan **(SIH-ber-ehkts)**
Flemish (1627–1703)

FAST FACTS

Painter, writer | signed the first Futurist manifesto | mix of Cubist and Futurist styles | *Suburban Train Arriving in Paris,* 1915 (The Tate Gallery, London, England)

Painter, photographer | *The Passion of Sacco and Vanzetti,* 1931–32 (Whitney Museum of Art, NYC)

Painter, photographer | industrial themes | *City Interior,* 1936 (Worcester Art Museum, Worcester, Massachusetts)

Photographer | performance | film stills | *Untitled,* 1979 (Metro Pictures, NYC)

Landscape painter | scenes of grand country estates | *A View of Longleat,* 1675 (PC)

SICKERT, Walter **(SIK-ert)**
English (1860–1942)

SIGNAC, Paul **(seen-yak)**
French (1863–1935)

SIGNORELLI, Luca **(seen-yor-EL-lee)**
Italian (1445–1523)

SIQUEIROS, David **(see-KAY-ros)**
Mexican (1896–1974)

SISKIND, Aaron **(SIS-kind)**
American (1903–1991)

314

Painter | landscapes, portraits, theatre, music halls |
Ennui, c. 1914 (The Tate Gallery, London, England)

Painter | Pointillist | mosaic-like effects by use of broad
brushstrokes | *Pont Neuf,* Paris (National Gallery of Art,
Washington, DC)

Painter | *The Death and Testament of Moses,* 1480 (fresco in
the Sistine Chapel, The Vatican, Rome, Italy)

Muralist painter | leading figure in mural painting of the
20thc | *For the Full Safety and Social Security at Work of
All Mexicans,* 1952-54 (La Raza Hospital, Mexico City, Mexico)

Photographer | abstract images of planes and surfaces |
Places: Aaron Siskind Photographs, published in 1976

SISLEY, Alfred **(siz-lee)**
French (1839–1899)

SITTOW, Michel **(SIT-tow)**
Netherlandish (1469–1525)

SLOAN, John **(SLONE)**
American (1871–1951)

SLUTER, Claus **(SLOO-ter)**
Dutch (active 1380–1405)

SMITH, David **(SMITH)**
American (1906–1965)

SMITH, Tony **(SMITH)**
American (1912–1980)

FAST FACTS

Painter | *Montmartre from the Cité des Fleurs,* 1869 (Musée des Beaux-Arts, Grenoble, France)

Painter | *Katherine of Aragon,* c. 1503-04 (Kunsthistorisches Museum, Vienna Austria)

Painter | member of "The Eight" | *The Haymarket,* 1907 (Brooklyn Museum, Brooklyn, New York)

Sculptor | intensely naturalistic figures | *The Well of Moses*, 1395–1406 (Chartreuse de Champol, Dijon, France)

Abstract sculptor and painter | *Circle I, Circle II, Circle III,* 1962 (National Gallery of Art, Washington, DC)

Sculptor | *Wandering Rocks,* 1967 (National Gallery of Art, Washington, DC)

SMITHSON, Robert **(SMITH-sun)**
American (1938–1974)

SNYDERS, Frans **(SNY-derz)**
Flemish (1579–1657)

SODOMA, IL (SAH-do-muh) Giovanni Antonio Bazzi
Italian (1477–1549)

SOULAGES, Pierre **(soo-LAZH)**
French (b. 1919)

SOUTINE, Chaim **(soo-TEEN)**
French (b. Russia 1894–1943)

SPENCER, Lily Martin **(SPEN-ser)**
America f (b. England 1822–1902)

Installation artist | Earthworks | *Spiral Jetty in the Great Salt Lake,* Utah, 1970 (now submerged) (Great Salt Lake, Utah)

Painter | still-life and animal painting | *The Fruit-Seller,* before 1636 (Prado, Madrid, Spain)

Religious and history painter | *Saint Sebastian,* 1525 (Palazzo Pitti, Florence, Italy)

Painter | painted with palette knives, spatula, and even the sole of his shoe

Expressionist painter | paintings of carcasses | *The Carcase of an Ox,* 1925 (Albright-Knox Art Gallery, Buffalo, New York)

Painter | portraits of children | *We Both Must Fade* (Mrs. Frithian), 1869 (National Museum of American Art, Washington, DC)

SPENCER, Sir Stanley **(SPEN-ser)**
English (1891–1959)

SPILLIAERT, Léon **(SPIL-ahrt)**
Belgian (1881–1946)

STAËL, Nicolas de **(STAHL)**
French (b. Russia 1914–1955)

STEEN, Jan **(STANE)**
Dutch (1625–1679)

STEICHEN, Edward **(STY-khen)**
American (b. Luxembourg 1879–1973)

FAST FACTS

Painter | *The Resurrection, Cookham,* 1923–26 (The Tate Gallery, London, England)

Painter | *Le Vertige,* 1908 (Musée des Beaux-Arts, Ostend, Belgium)

Painter, engraver | brilliant colors | *Abstract Figure by the Sea,* 1952 (Kunststammlung Nordrhein-Westfalen, Düsseldorf, Germany)

Painter | *The Doctor's Visit,* c. 1665 (Mauritshuis, The Hague, The Netherlands)

Photographer | a founding member of the Photo-Secession | fashion photos for *Vanity Fair* and *Vogue* magazines | *Marlene Dietrich, New York,* 1932 (The Museum of Modern Art, NYC)

STELLA, Frank **(STEL-luh)**
American (b. 1936)

STEVENS, Alfred **(STAY-vens)**
Belgian (1823–1906)

STIEGLITZ, Alfred **(STEE-glits)**
American (1864–1946)

STILL, Clyfford **(STIL)**
American (1904–1980)

STRAND, Paul **(STRAND)**
American (1890–1976)

Painter, sculptor | shaped canvases | "notched" paintings | *Battle of Light, Coney Island,* 1913 (Yale University Art Gallery, New Haven, Connecticut)

Sculptor, architect, designer, painter | *Ce qu'on appelle le Vagabondage,* 1855 (Musée d'Orsay, Paris, France)

Photographer | "straight," unmanipulated photographs | member of the Photo-Secession | *Hand and Wheel (O'Keeffe Hand and Ford Wheel),* 1933 (The Cleveland Museum of Art, Cleveland, Ohio)

Painter | rough, heavily painted canvases | *Painting,* 1944 (The Museum of Modern of Art, NYC)

Abstract photographer | *Porch Shadows, Connecticut,* 1915 (The Dan Berley Collection)

 NAME • (PRONUNCIATION) • Nationality • (dates)

STROZZI, Bernardo **(STROHT-see)**
Genoese (1581–1664)

STUART, Gilbert **(STOO-ert)**
American (1755–1828)

STUBBS, George **(STUBS)**
English (1724–1806)

SULLY, Thomas **(SUL-lee)**
American (1783–1872)

SUTHERLAND, Graham **(SUTH-er-land)**
English (1903–1980)

FAST FACTS

Painter │ called "Il Cappuccino" │ *Old Woman at the Mirror* (Pushkin Museum, Moscow, Russia)

Portrait painter │ *George Washington,* 1795 (The Metropolitan Museum of Art, NYC)

Portrait painter │ horses and the sporting aristocracy │ *The Milbanke and Melbourne Families,* c. 1770 (The National Gallery, London, England)

Portrait painter │ painted almost 3000 works │ *Fanny Kemble,* 1834 (The White House, Washington, DC)

Painter, graphic artist, designer │ semi-abstract style │ *The Origins of the World,* 1951 (The Tate Gallery, London, England)

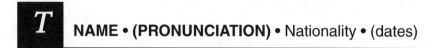

TAKIS, Panayiotis Vassilakis **(TAH-kis)**
Greek (b. 1925)

TAMAYO, Rufino **(tuh-MY-oh)**
Mexican (b. 1899)

TANGUY, Yves **(tan-GEE)**
American (b. France 1900–1955)

TANNER, Henry Ossawa **(TAN-ner)**
American (1859–1937)

TANSEY, Mark **(TAN-zee)**
American (b. 1949)

Kinetic art sculptor | wind-driven, stainless steel, abstract sculptures | *Magnetic Ballet,* 1986 (Musée National d'Art Moderne, Centre Pompidou, Paris, France)

Painter, muralist | murals in the UNESCO building (Paris, France)

Surrealist painter | nonfigurative, bizarre images on deserted landscapes | *Fear,* 1949 (Whitney Museum of American Art, NYC)

Painter | scenes of African-American life | *The Banjo Lesson,* c. 1893 (Hampton Institute, Hampton, Virginia)

Postmodernist painter | explores the role of the mass media in the art world | *Triumph of the New York School,* 1984 (Whitney Museum of American Art, NYC)

TÀPIES, Antoni **(TAHP-yes)**
Spanish (b. 1923)

TATLIN, Vladimir **(TAHT-lin)**
Russian (1885–1953)

TENIERS, David, the Elder **(ten-EERS)**
Flemish (1582–1649)

TER BORCH, Gerard **(ter BORK)**
Dutch (c. 1617–1681)

TERBRUGGHEN, Hendrick **(ter-BROOK-en)**
Dutch (1588–1629)

THIEBAUD, Wayne **(TEE-boe)**
American (b. 1920)

Painter, sculptor | collages incorporating found objects | a founder of the El Paso group, 1957

Painter, designer | a founder of Russian Constructivism

Painter | genre and historical paintings, portraits, landscapes

Painter | genre paintings and portraits | *The Visitor's Suite,* c. 1658 (National Gallery of Art, Washington, DC)

Painter | *Boy with Wine Glass,* 1623 (North Carolina Museum of Art, Raleigh, North Carolina)

Painter, teacher | lushly painted still lifes of food | *Cakes,* 1963 (National Gallery of Art, Washington, DC)

THOMAS, Alma **(TOM-as)**
American f (1891–1978)

TIEPOLO, Giandomenico **(tee-EH-poe-loe)**
Italian (1727–1804)

TIEPOLO, Giovanni Battista **(tee-EH-poe-loe)**
Italian/Venetian (1696–1770)

TINGUELY, Jean **(ta(n)-glee)**
Swiss (b. 1925)

TINTORETTO Jacopo Robusti **(tin-tor-ET-toe)**
Italian/Venetian (1519–1594)

FAST FACTS

Abstract painter | associated with the Washington Color School | *Cherry Blossom Symphony,* (National Gallery of Art, Washington, DC)

Painter | son of artist Giovanni Battista Tiepolo | *The Winter Promenade,* 1757 (Villa Valmarana)

Rococo painter | fresco paintings for churches | easel paintings, altarpieces, ceilings | *Ceiling fresco of the Kaisersaal,* 1751 (Episcopal Palace, Würzburg, Germany)

Sculptor and painter | assemblages of found objects | *Homage to New York: A Self-Constructing and Self-Destroying Work of Art,* 1960 (Museum of Modern Art, NYC)

Painter | commissioned to adorn Venetian public buildings | *The Origin of the Milky Way,* c. 1580 (The National Gallery, London, England)

 NAME • (PRONUNCIATION) • Nationality • (dates)

TISSOT, James **(tee-SOE)**
French (1836–1902)

TITIAN (TI-shen) (Tiziano Vecelli)
Italian/Venetian (c. 1477–1576)

TOBEY, Mark **(TOE-bee)**
American (1890–1976)

TOULOUSE-LAUTREC, Henri de **(too-LOOZ loe-trek)**
French (1864–1901)

TROY, Jean François de **(TWAH)**
French (1679–1752)

FAST FACTS

Painter | *Hide and Seek,* c. 1877 (National Gallery of Art, Washington, DC)

Painter | *The Venus of Urbino,* c. 1538 (Galleria degli Uffizi, Florence, Italy) | *Danaë,* 1545–46 (Museo di Capodimonte, Naples, Italy)

Painter | developed "white writing" technique | *Forms Follow Man,* 1941 (Seattle Art Museum, Seattle, Washington)

Post-Impressionist painter, poster designer | Paris cabaret scenes | *At the Moulin Rouge,* 1892 (The Art Insitute of Chicago, Chicago, Illinois)

Genre painter, portraitist, decorator | *The Oyster Lunch,* 1735 (Musée Condé, Chantilly, France)

TRUMBULL, John **(TRUM-bull)**
American (1756–1843)

TURNER, Joseph Mallord William **(TER-ner)**
English (1775–1851)

TWACHTMAN, John Henry **(TWAHKT-man)**
American (1853–1902)

TWOMBLY, Cy **(TWAHM-blee)**
American (b. 1929)

History painter | portraits | *The Death of General Warren at the Battle of Bunker's Hill, June 17, 1775,* 1786 (Yale Universiy Art Gallery, New Haven, Connecticut)

Painter | landscapes and seascapes with Romantic lighting | influenced the Impressionists | *Slave Ship,* 1839 (Museum of Fine Arts, Boston)

Impressionist painter | member of The Ten Americans | *Icebound,* 1889–1902 (The Art Institute of Chicago, Chicago, Illinois)

Abstract painter | haphazard scribbling, lettering, and gestural techniques | automatic writing | *Wilder Shores of Love,* 1985 | *Untitled,* 1969 (Whitney Museum of American Art)

UCCELLO, Paolo **(oo-CHEL-loe)**
Italian/Florentine (1397–1475)

UTAMARO, Kitagawa **(oo-tuh-MAH-roe)**
Japanese (1753–1806)

UTRILLO, Maurice **(oo-TREE-oh)**
French (1883–1955)

NOTES:

Painter | nickname "Uccello" means bird in Italian | frescoes, panel paintings | *The Battle of San Romano,* c. 1456 (Galleria degli Uffizi, Florence, Italy)

Painter, engraver | Ukiyo-e technique | his wood-block color prints inspired artist Mary Cassett | *Women Making Dresses,* c. mid 1790s (Tokyo National Museum, Tokyo, Japan)

Painter | scenes depicting Montmartre, Paris | son of artist Suzanne Valadon | *Église de Saint Bernard* (The University of Arizona Art Gallery, Tucson, Arizona)

VALADON, Suzanne **(va-lah-doh(n))**
French *f* (1867–1938)

VALLOTTON, Félix **(val-loe-toh(n))**
French (b. Switzerland 1865–1925)

VASARELY, Victor **(vah-zah-ray-lee)**
French (b. Hungary 1908)

VASARI, Giorgio **(vah-SAH-ree)**
Italian/Florentine (1511–1574)

VELÁZQUEZ, Diego Rodríguez de Silva y **(ve-LAHZ-kez)**
Spanish (1599–1660)

Painter, draftswoman | mother of artist Maurice Utrillo | nude female forms | *Grandmother and Young Girl Stepping into the Bath,* c. 1908 (PC)

Painter, printmaker, illustrator, writer | *La Malade,* 1892 (Vallotton Collection)

Painter | Bauhaus theory | Constructivism | *Mindanao,* 1952–55 (Albright-Knox Art Gallery, Buffalo, New York)

Painter, architect | well known as an art historian and critic | designed The Uffizi in Florence | *Lives of the Most Eminent Italian Architects, Painters, and Sculptors,* 1550

Painter | *Las Meniñas,* 1656 (title is Spanish for Maids of Honor) (Museo del Prado, Madrid, Spain)

 NAME • (PRONUNCIATION) • Nationality • (dates)

VELDE, Henry van de **(VEL-duh)**
Belgian (1863–1957)

VERMEER Jan, of Delft **(fer-MEER)**
Dutch (1632–1675)

VERNET, Horace **(vare-NAY)**
French (1789–1863)

VERONESE, Paolo **(ver-roe-NAY-zee)**
Italian/Venetian (1528–1588)

VERROCCHIO, Andrea del **(ver-ROE-kee-oh)**
Italian/Florentine (1435–1488)

FAST FACTS

Art Nouveau painter, decorative arts designer, architect |
landscapes | designed a theater for the Werkbund
Exhibition in 1914, since destroyed (Cologne, Germany)

Painter | less than 40 paintings are known to exist |depict-
ed domestic life | *The Lace Maker* (Musée du Louvre,Paris,France)
| *The Love Letter,* c. 1666 (Rijkmuseum, Amsterdam, Holland)

Painter, lithographer | battles, military, and sporting scenes
| horses as subjects

Painter | *Mars and Venus United by Love,* (The Metropolitan
Museum of Art, NYC)

Sculptor, painter, goldsmith | *The Baptism of Christ,* c. 1475
(Galleria degli Uffizi, Florence, Italy)

VIEIRA DA SILVA, Maria Elena **(vee-EH-ruh da SIL-vuh)**
French *f* (1908–1956)

VIGEE-LEBRUN, Elizabeth **(VEE-zhay leh BREH(N))**
French *f* (1755–1842)

VILLON, Jacques **(vee-YOHN)**
French (1875–1963)

VIOLA, Bill **(vy-OH-luh)** American (b. 1951)

VLAMINCK, Maurice de **(vlah-MINK)**
French (1876–1958)

FAST FACTS

Painter, printmaker, tapestry designer | active in France |
Checkmate, 1949–50 (PC)

Rococo painter | portraits of the aristocracy | portraitist to
Queen Marie Antoinette | *The Princesse de Polignac,* 1783
(The Courtauld Institute of Art, London, England)

Cubist painter | *The Table,* 1912 | half-brother of artist
Marcel Duchamp | *The Game of Solitaire,* 1903 (The Museum
of Modern Art, NYC)

Video artist | installations | *I Do Not Know What It Is I
Am Like,* 1986 | *To Pray Without Ceasing,* 1992 (PC)

Painter, graphic artist, writer | member of the Fauves |
The Park, 1894 (The Museum of Modern Art, NYC)

VONNOH, Bessie Potter **(VAHN-oh)**
American *f* (1872–1855)

VOUET, Simon **(voo-AY)**
French (1590–1649)

VUILLARD, Édouard **(vwee-YAR)**
French (1868–1940)

NOTES:

Sculptor | small genre pieces | *The Fan,* c. 1910 (National Museum of Women in the Arts, Washington, DC)

Baroque painter | portraits | decorative painting | *The Allegory of Prudence* (Musée du Louvre, Paris, France)

Painter | member of the Nabis | *Woman in a Striped Dress,* 1895 (National Gallery of Art, Washington, DC)

 NAME • (PRONUNCIATION) • Nationality • (dates)

WADSWORTH, Edward **(WAHDS-werth)**
British (1889–1949)

WALLIS, Alfred **(WAL-lis)**
British (1855–1942)

WARD, John Quincy Adams **(WAURD)**
American (1830–1910)

WARHOL, Andy **(WAUR-hall)**
American (1928–1987)

WATERHOUSE, John William **(WAU-ter-howce)**
British (1849–1917)

FAST FACTS

Painter | maritime themes | *The Beached Margin,* 1937
(The Tate Gallery, London, England)

Painter | primitive nautical themes | *Saint Ives with Godrevy Lighthouse,* c. 1935 (PC)

Sculptor | naturalist portraits

Pop artist and commercial illustrator | silkscreens | *Green Coca-Cola Bottles,* 1962 (Whitney Museum of American Art, NYC) | *Marilyn Diptych,* 1962 (The Tate Gallery, London, England)

Painter | follower of the Pre-Raphaelites | *The Lady of Shalott,* 1888 (The Tate Gallery, London, England)

WATKINS, Carleton E. **(WAHT-kins)**
American (1825–1916)

WATTEAU, Jean-Antoine **(VAH-toe)**
French (1684–1721)

WEBER, Max **(VAY-ber)**
American (b. Russia 1881–1961)

WEEGEE, (wee-jee) (Arthur Fellig)
American (b. Poland 1899–1968)

WEENIX, Jan Baptist **(VAY-niks)**
Dutch (1621–1664)

FAST FACTS

Photographer | one of the earliest to photograph the West in the 1860s and 1870s | *Cathedral Rock, 2,600 Feet, Yosemite, No. 21,* c. 1866 (The Metropolitan Museum of Art, NYC)

Painter | *The Embarkation for Cythera,* 1718 (Schloss Charlottenburg, Berlin, Germany)

Abstract painter, sculptor | explored the lively rhythms of the city | *A Dispute,* c. 1939 (Detroit Institute of Arts, Detroit,Michigan) | *Chinese Restaurant,* 1915 (Whitney Museum of American Art, NYC)

Photographer | *The Critic,* 1943 (Lunn Gallery/ Graphics International, Ltd., Washington, DC)

Painter, printmaker | landscapes and seaports | still lifes | portraits

WEIGHT, Carel **(VATE)**
British (1908–1962)

WEIR, Julian Alden **(WEER)**
American (1852–1919)

WESSELMANN, Tom **(WES-el-man)**
American (b. 1931)

WEST, Benjamin **(WEST)**
American (1738–1820)

WESTON, Edward **(WES-tun)**
American (1886–1958)

FAST FACTS

Painter | haunting ghosts, spirits, and witches

Painter, printmaker | American Impressionist | *Upland Pasture*, c. 1905 (National Musuem of American Art, Washington, DC)

Pop artist | assemblages, collages | *The Great American Nude No. 27*, 1962 (series) (Mayor Gallery, London, England)

History painter | called "the Father of American painting" | *Penn's Treaty with the Indians,* 1771 (Pennsylvania Academy of the Fine Arts, Philadelphia, Pennsylvania)

Photographer | California landscapes | portraits, close-up still-life studies | *Pepper,* 1930 (Center for Creative Photography, Tucson, Arizona)

WEYDEN, Rogier van der **(VY-den)**
Netherlandish (c. 1399–1464)

WHISTLER, James Abbott McNeill **(WIST-ler)**
American, lived in France and Italy (1834–1903)

WHITE, Clarence **(WYTE)**
American (1871–1925)

WILKIE, David **(WIL-kee)**
Scottish (1785–1841)

WILSON, Richard **(WIL-sun)**
English (1714–1782)

FAST FACTS

Painter | portraits, religious subjects | *The Deposition,* or
The Descent from the Cross, c. 1435 (Museo del Prado, Madrid,
Spain)

Painter | waterscapes | *Arrangement in Black and Gray:
Portrait of the Artist's Mother,* 1871 (commonly referred to as
Whistler's Mother) (Musée du Louvre, Paris, France)

Photographer | collaborated with Alfred Stieglitz | *Nude
Figure*, 1910

Painter | *Blind Man's Bluff,* 1812 (Buckingham Palace, Royal
Collection, London, England)

Painter | *Interior with Harpsichord,* 1667 (Museum Boymans-van
Beuningen, Rotterdam, Holland)

WINOGRAND, Garry **(WIH-noe-grand)**
American (1928–1984)

WINTERHALTER, Franz Xaver **(WIN-ter-HALL-ter)**
German (1806–1873)

WITZ, Konrad **(VITS)**
German (1400–1445)

WOHLGEMUTH, Michael **(VOLE-ge-moot)**
German (1434–1519)

WOOD, Grant **(WOOD)**
American (1892–1942)

Photographer | portrayed American culture | *Park Avenue, New York,* 1959 (The Museum of Modern Art, NYC)

Painter, portraitist, lithographer | some works at the Palace of Versailles, France | Prince Albert of Saxe-Coburg-Gotha, 1867 (The National Portrait Gallery, London, England)

Painter | very few works have survived | *Saint Catherine and Saint Mary Magdalene* (Musée de l'Oeuvre-Notre-Dame, Strasbourg, France)

Painter, engraver | altarpieces | woodcut designs | teacher of Albrecht Dürer

Regionalist painter | satirical paintings | *American Gothic,* 1930 (The Art Institute of Chicago, Chicago, Illinois)

NAME • **(PRONUNCIATION)** • Nationality • (dates)

WOODVILLE, Richard Caton **(WOOD-vil)**
American (1825–1855)

WRIGHT, Frank Lloyd **(RITE)**
American (1867–1959)

WRIGHT of DERBY, Joseph **(RITE uv DAHRBY)**
English (1734–1797)

WYETH, Andrew **(WY-eth)**
American (b. 1917)

WYETH, N.C. (Newell Convers) **(WY-eth)**
American (1882–1945)

FAST FACTS

Painter | genre scenes | historical subjects

Architect | *Guggenheim Museum of Art,* 1959 (NYC) | "Prairie" houses | *Falling Water,* 1936 (near Pittsburgh, Pennsylvania)

Painter | *Experiment with the Air Pump,* c. 1767–68 (The Tate Gallery, London, England)

Realist painter | watercolors, tempera, drypoint | rural life in Pennsylvania and Maine | *Christina's World ,* 1948 (The Museum of Modern Art, NYC)

Noted book illustrator and painter | *The Last of the Mohicans* | father of artist Andrew Wyeth | *Barn in Winter,* c. 1907 (The White House, Washington, DC)

NAME • (PRONUNCIATION) • Nationality • (dates)

YAMAGATA, Hiro **(yah-muh-gah-tuh)**
Japanese (b. 1949)

YEATS, Jack Butler **(YATES)**
Irish (1871–1957)

NOTES:

FAST FACTS

Painter | minutely detailed street and museum scenes of Paris | lives in Los Angeles

Painter, illustrator | scenes of Irish life | his works resemble the loose style of Oskar Kokoschka | *South Pacific*

(Murray Collection, Scranton, Pennsylvania)

ZEUXIS (ZOOK-sis)
Greek (late 5th century BC)

ZOFFANY, Johann **(ZOHF-fah-nee)**
Anglo-German (1733–1810)

ZORN, Anders **(TZORN)**
Swedish (1860–1920)

ZUCCARELLI, Francesco **(zoo-kah-REL-lee)**
Italian/Venetian (1702–1788)

ZURBARÁN, Francisco de **(zur-bah-RAHN)**
Spanish (1598–1664)

FAST FACTS

Painter | master of "trompe-l'oeil" | student of
Apollodoros | no known works survive

Painter | portraits, conversation pieces | fresco of
The Donation of Charlemagne (Sala Regina, The Vatican, Rome)

Printmaker, sculptor, painter | scenes of peasant life |
studies of Marcel Proust and Auguste Rodin | *William
Howard Taft,* 1911 (The White House, Washington, DC)

Painter | idyllic river and countryside scenes | paintings
in the Royal Collection, Windsor Castle, London, England

Painter | still lifes | religious subjects | *Saint Francis in
Meditation,* c. 1639 (The National Gallery of Art, London, England)

References

Beckett, Sister Wendy. *The Story of Painting*. New York: Dorling Kindersly, 1994.

Hartt, Frederick. *Art: A History of Painting, Sculpture, Architecture*. Englewood Cliffs N.J.: Prentice Hall Inc., & New York: Harry N, Abrams, Inc. 4th edition, 1993

Jacobs, Jay. *The Color Encyclopedia of World Art*. New York: Crown Publishers, 1975.

Janson, H.W. *The History of Art*. New York: Harry N. Abrams, Inc., 3rd edition, 1986.

Lucie-Smith, Edward. *Late Modern: The Visual Arts Since 1945*. New York: Frederick A. Praeger, Inc., 1969.

Piper, David. *The Illustrated History of Art*. Avenel, N.J: Random House, 1994.

Vaizey, Marina. *100 Famous Paintings*. Stamford, Conn: Longmeadow Press, 1994.

Wood, Michael, et al. *Art of the Western World from Ancient Greece to Post-Modernism*. New York: Summit Books, 1989.

_____. *American Paintings, An Illustrated Catalogue*. Washington, DC: National Gallery of Art, 1992.

_____. *The Art Book*. London, England: Phaidon Press Limited, 1994.

_____. *Art of this Century, The Guggenheim Museum and Its Collection*. New York: Guggenheim Museum Publications, 1993.

_____. *Art for the Nation: Gifts in Honor of the 50th Anniversary of the National Gallery of Art*. Washington, DC: National Gallery of Art, 1991.

_____. *ArtScreens*. Arlington, VA: Trident Software, 1993.

_____. *Cambridge Bio-Graphical Dictionary*. Cambridge, England: Cambridge University Press, 1990.

_____. *Dictionary of Art and Artists*. London: Thames and Hudson, 1985.

_____. *Collections Handbook.* Indianapolis, IN: Indianapolis Museum of Art, 1988.
_____. *Dictionary of the Arts, Facts on File.* London: Helicon Publishing, Limited, 1994.
_____. *The Essential Guide to the Art Institute of Chicago.* Chicago: The Art Institute of Chicago, 1993.
_____. *European Paintings, An Illustrated Catalogue.* Washington, DC: National Gallery of Art, 1985.
_____. *Great French Paintings From The Barnes Foundation.* New York: Alfred A. Knopf, Inc., 1993.
_____. *The Larousse Dictionary of Painters.* New York: Mallard Press, 1989.
_____. *The Museum of Modern Art, New York: The History and The Collection.* New York: Harry N. Abrams, Inc., 1993.
_____. *National Gallery of Art, Washington.* London: Thames and Hudson, 1992.
_____. *Pronunciation Dictionary of Artists' Names.* Chicago: The Art Institute of Chicago, 1993.
_____. *The Random House Biographical Dictionary.* New York: Randon House, 1992.
_____. *Sculpture: An Illustrated Catalogue.* Washington, DC: National Gallery of Art, 1994.
_____. *Treasures from the National Museum of American Art.* Washington, DC: Smithsonian Institution Press, 1985.
_____. *Whitney Museum of American Art, Selected Works from the Permanent Collection.* New York: W.W. Norton & Co. New York, 1994

NOTES:

NOTES:

NOTES: